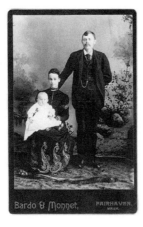

Dating Nineteenth Century Photographs

ROBERT POLS

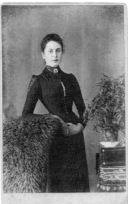

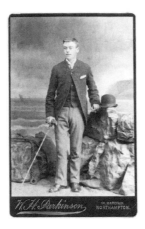

Published by
The Federation of Family History Societies (Publications) Ltd
Units 15-16, Chesham Industrial Centre
Oram Street, Bury
Lancashire BL9 6EN

© Robert Pols

ISBN: 1 86006 188 5

First published 2005

This book and its companion
Dating Twentieth Century Photographs
replaces the previous publication
Dating Old Photgraphs

Printed and bound at The Alden Press
Osney Mead, Oxford OX1 0EF

Contents

Introduction

"Depicted by the solar rays, What loveliness this form displays!" enthused Punch contributor Percival Leigh in 1862. "I consider photographs wanting in mellowness as a general rule and making you look like a new ploughed field," grumbled Dickens' creation Mrs Lirriper in 1863. But like it or hate it (and most liked it), the photograph had reached new heights of popularity in the early 1860s, and a portrait was no longer within reach of only the well-to-do. At the beginning of Queen Victoria's reign, the invention of photography was announced; by its end, the day of the snapshot had dawned. The story of the intervening years is the story of a love affair, as, class by class, the public became enamoured of the new art.

Photography was and is a staggering invention. It brought our ancestors face to face with themselves, and it brings us face to face with them. Not surprisingly, therefore, photographs form an important and treasured part of many a family archive. Whether they come in a full set of albums or survive as a battered handful of pictures, they provide a window through which we can gain a glimpse of our own past. But the view through the window is not always clear, and the aim of this small book is to help bring it into focus.

More precisely, the intention is to help with the understanding, identification and dating of Victorian photographs. The original book, *Dating Old Photographs*, dealt with the period up to the First World War, but it has since become apparent that more could be said about the twentieth century than was originally attempted. The resulting revision and expansion of treatment has led to two volumes of which this, the first, concentrates on the 19th century. Many minor revisions have been made to the original text, fresh material relating to identification and dating has been introduced, and new sections have been added. All the dating charts have been reworked, with extra ones being added, and a number of new illustrations make an appearance.

Discussion of Edwardian and early Georgian photographs has migrated to the new companion work, *Dating Twentieth Century Photographs*, which covers a greatly enlarged time span and presents much new material.

The Beginnings of Photography

The Effects of Light

The origins of photography lie in two sciences: optics and chemistry.

Optically, the ancestor of photography is the camera obscura. The way in which light could form pinhole images seems to have been known to the scholars of ancient China, but the first published description of the camera obscura (literally: 'dark chamber') was written by Giovanni Battista della Porta in 1558.

To gain an idea of the camera obscura, imagine a closed, darkened room. One interior wall is painted white, and a pinhole is made in the opposite wall. In good light, a picture of the scene outside the room appears upside down on the white wall. This image can be turned the right way up, made brighter and defined more clearly by the use of a lens instead of a pinhole. This, in essence, is the camera obscura, which captured light's ability to form images.

Light can also have chemical effects. It can work on some materials to make them paler, as testified by the faded spines of books on shelves that catch the sunlight. This action of sunlight was an important ingredient in the early bleaching industry. Conversely, some materials darken in the sun's rays, as is firmly understood by the heliotropic thousands who flock to the beach each summer. For some two hundred years before photography it was known that silver salts (now known as silver halides) darken when exposed to light. What was not possible, until the nineteenth century, was the ability to control and, when necessary, arrest this darkening process.

Prehistory

In the years that followed della Porta's account, the camera obscura underwent modifications. By the use of mirrors, the image could be directed away from the white wall and on to a sheet of paper, where it could then be traced. What worked with a darkened room could work with a darkened box, so a portable camera obscura became a possibility. When the screen on which the image fell was made of translucent paper or ground glass, the image

could be seen from outside the box. Thus the camera obscura came to be widely recognised as an aid to artists, especially in their struggles to master perspective. Further experiments with mirrors and lenses and, in particular, the invention of a movable lens tube to permit focusing, all helped to refine the device, so that by the end of the 17th century the basic camera already existed. What was lacking and what would stay lacking — for another 150 years — was the ability to preserve the image rather than to simply trace it.

It was to this problem that a knowledge of the chemical effects of light was eventually applied. The first recorded attempt to produce photographic images, described by Sir Humphrey Davy in 1802, was carried out by Thomas Wedgwood at the end of the 18th century. By placing objects upon materials treated with silver salts, Wedgwood was able to obtain images. Where the light hit the sensitised material, the surface darkened; where the object blocked out the light, the surface remained pale. Unfortunately, Wedgwood was unable to neutralise the sensitivity and fix his images. He was therefore unable to view them by daylight. The next steps would be to use a light-sensitised material as the image-receiving screen in a camera, and to halt the chemical process so that the resulting picture could be retained.

The Earliest Photograph

The first person to combine the optical properties of light with its chemical effects and then preserve the result was Joseph Nicéphore Niépce, a veteran of Napoleon's army. By 1827, after some years of trying, Niépce managed to produce reasonably successful fixed pictures of a courtyard view taken from his attic window. After experimenting with silver salts, he turned to the use of bitumen of Judea, a light-sensitive asphalt-like substance that was used in lithography. A plate of polished pewter was coated with varnish containing bitumen of Judea and exposed in a camera. Where affected by light, the bitumen hardened and turned pale. The remaining, unhardened varnish, corresponding to the dark areas of the image, was then washed off with a solvent of petroleum to re-expose the metal beneath. The picture was thus made up of pale hardened areas and patches of bare pewter. The contrast could then be improved by treatment with iodine vapour, which further darkened the uncovered metal.

A picture of Niépce's courtyard survives, and the result is a faint pattern of light and shade with very little definition. It also took an eight-hour

exposure to the light to produce. Photography had started, but it still had far to go, and these early efforts were not enough to capture the popular imagination or to create an industry.

The Daguerreotype

One man who was impressed by Niépce's work was Louis Daguerre, a scene-painter and the owner of the Paris Diorama. He sought out Niépce and, in 1829, went into partnership with him. The process which he developed over the following ten years was rather different from that pioneered by his colleague, and Niépce died in 1833 before he could see their joint effort brought to its successful conclusion.

On 7th January 1839 the Director of the Paris Observatory announced to the world that Daguerre had devised a method of fixing a reproduced image. The invention was called, with justifiable pride, the 'daguerreotype'.

Daguerre's method was to cover a copper plate with a thin coating of silver. The plate, having been highly polished, was then treated with iodine, the fumes of which worked on the silvered surface to produce a light-sensitive layer of silver iodide (or iodine of silver, as it was then known). The plate was exposed in a camera and the image then brought out by the action of mercury vapour. The problem of stopping the chemical action and fixing the image was at first solved by the use of common salt. But Daguerre quickly turned to the use of hypo, which was promoted as a fixing agent later in the same year, and of which more will be said in due course.

The resulting daguerreotype was essentially a negative image: the light parts of the original scene appeared dark on the silvered plate. But just as a modern black and white negative can appear positive when viewed at the right angle, so could the daguerreotype. The picture, though faint, was remarkably well defined.

The early daguerreotypes had their limitations. Exposures of ten minutes or more were necessary, and, in less than ideal light, over half an hour was occasionally needed. Scenes could be captured, because scenery stood still. People or horses passing by showed up as no more than a blur, and clocks appeared to have only hour hands. But as others took up the process, it was improved. Richard Beard and Antoine Claudet discovered, for example, that bromine acted as an accelerator, speeding up the rate at which the chemicals reacted to light. This led in the early 1840s to exposure times being reduced

to one or two minutes. Portraits were now possible, and that possibility was very quickly explored and turned into a reality. (In 1849, in Paris alone, 100,000 people posed for their photographs.)

The Calotype

The announcement of Daguerre's process caused some concern to William Henry Fox Talbot, for he too had been working on ways of making camera images permanent, and had achieved successful results as early as 1835. Frustrated by his own attempts at sketching, Fox Talbot had, on returning from his honeymoon tour of Europe, settled down at his Lacock Abbey home to tackle the same problems as Daguerre was working on. His solution was rather different.

Fox Talbot used paper rather than metal as the basis for his photographic plate. His earliest work followed on from that of Wedgwood. First he brushed sheets of writing paper with a weak solution of salt and soaked them in a strong solution of silver nitrate. He then placed such items as leaves, lace, flowers and feathers on the treated paper and exposed object and paper to sunlight. Where light reached the paper, through holes in lace or gaps between leaves (as well as on the outer uncovered areas) the sensitised surface turned dark. Where the object itself prevented light from reaching it, the paper remained white. Talbot called these pictures 'photogenic drawings'. From here it was but a short step to using the treated paper as the plate in a camera.

The product so far of Fox Talbot's process was a negative image, with the light parts of the original subject showing dark on the picture. But he realised that positives could be made by placing the negative over a second sheet of treated paper. Light would filter through the pale parts of the negative and darken the paper beneath, thus reversing the blacks and whites, and producing an image in which the light values were those of the subject.

For his very earliest pictures, Fox Talbot used potassium iodide as the fixing agent. But this gave a yellowish quality to the highlights, and he quickly changed to the use of common salt solution. This acted by converting any remaining light-sensitive silver nitrate to non-sensitive silver chloride. It was, though, a method that produced a colour cast: the white parts of the picture took on a pale lilac tint within a few hours of fixing.

Although Fox Talbot's earliest pictures dated from 1835, he had published nothing about his discoveries until the 1839 announcement of Daguerre's success stole his thunder and stung him into action. He now acted quickly, and on the last day of January read a paper about his process to the Royal Society.

At first his exposures took half an hour or more, but in 1840 he discovered the existence of a latent image that was capable of development. An exposure of between one and three minutes could produce an invisible image on the prepared paper, and this, given the appropriate chemical treatment, could be brought out after the picture had been taken. His developer (or 'exciting liquid' as he first called it) was gallic acid, and it had the incidental effect of improving the picture's quality.

By 1841 Fox Talbot was ready to patent his method, with gallic acid as the chemical accelerator. He called his improved process the 'calotype' and marketed licences for its use. The licences were taken up by only about a dozen people, and the following years were marked by some legal wrangling over patents into which crept an understandable degree of bitterness on Fox Talbot's part. But amongst those who bought a licence were David Octavius Hill and Robert Adamson, who set up in partnership in Edinburgh in 1843. Their initial aim was to provide portrait studies to help Hill, a painter, in the mammoth task of creating a picture to commemorate the first assembly of the Free Church of Scotland. They went on to take a series of impressive portraits during the few years before Adamson's death in 1848 at the age of 26.

During his lifetime, Fox Talbot made a series of improvements to the calotype process, including the waxing of the negative paper to make it more translucent, and the use of hypo as a fixing agent. Warmer tones were achieved by the inclusion of dilute nitric acid in the treatment used for the printing paper. The latent image principle was not used for the printing stage of the process, since, once the negative had been produced, time was no longer of the essence. For a while some of his friends applied the name 'Talbotype' to the process, but Talbot himself never promoted this, and it was his term, 'calotype', which stuck.

Fox Talbot was too late to prevent Daguerre from reaping the glory of being first in the field, and both men's processes were soon to become obsolete. At much the same time as they were creating their photographic

processes, Hippolyte Bayard was also achieving some experimental success with one-off images on a paper base. But, with hindsight, it is now possible to see Fox Talbot as the progenitor of mainstream chemical photography. It was his method which pointed the way forward: it was he who produced a negative-positive method which made possible multiple copies rather than the one-off image of the daguerreotype; and it was he whose work with the latent image set the agenda for later developments.

The earliest surviving photographic negative is of a window in Fox Talbot's home at Lacock Abbey. The home, with its attached photographic museum, can still be visited, though National Trust regulations now forbid indoor photography and, therefore, the capturing of the famous window from Fox Talbot's own viewpoint.

Hypo

1839 was a year for important announcements. Shortly after Daguerre and Fox Talbot had made their successes public, Sir John Herschel announced the use of hypo, or sodium thiosulphate, as a fixative. Herschel, a close friend of Fox Talbot, had discovered in 1819 that hypo dissolved silver salts, and so was immediately able to apply this knowledge to the search for a satisfactory fixing agent. By dissolving any light-sensitive silver salts that remained on the plate, negative or print, hypo rendered the surface stable and prevented any further reaction to light. Hypo was quickly adopted for fixing both daguerreotypes and calotypes, and was to go on to prove its worth with subsequent processes.

Whilst it is for hypo that Herschel is best known in the photographic field, it should be said that he also discovered the blueprint process, which was not to be taken up seriously until much later in the century, and devised a method for using treated glass rather than paper as the basis for a photograph. Because of the fragility of glass and the difficulties of handling it, Herschel and Fox Talbot both put this idea aside until rather later. Herschel also had an abiding influence on the language of photography, for the terms 'positive', 'negative' and 'snapshot' were all coined by him.

The Wet Collodion Process

Though Herschel and Fox Talbot did not persevere with the use of glass, Frederick Scott Archer did, and he employed it in what was perhaps the most important step forward of the age. In March 1851 he introduced his wet collodion process, which used glass negatives to produce paper prints. The method was faster than those which preceded it: a transparent glass plate negative could produce a print in a quarter of the time required for one made of waxed paper. Glass was also better as a negative because it did away with the textured, grainy effect that resulted from the fibrous structure of paper. The new process, therefore, found immediate favour with the professional photographer. It came into widespread use, portrait studios appeared all over the world, and even the dedicated amateur felt able to take up the activity as a hobby.

Yet this immense popularity arose in spite of the cumbersome nature of the process, for making wet collodion pictures was a major undertaking that involved 18 steps, all to be taken at some speed.

Collodion was gun-cotton dissolved in ether. It dried to create an airtight film and was used in hospitals to dress wounds. Whilst this drying property was invaluable in hospital, it caused a considerable problem for the photographer, who had to work with the sticky substance while it was still wet, and before the light-sensitive silver salts that were mixed into it were sealed in and rendered ineffective. The glass plate was coated in collodion that was allowed to become tacky. Then it was dipped into a bath of silver nitrate and used immediately. Once the plate had been exposed, and before the coating had time to dry, the latent image was developed, using pyro-gallic acid. The resulting negative could then be used to produce a positive print by laying it over sensitised paper and exposing again to the light. Alternatively, the glass negative, if deliberately thin and underexposed, could be treated and placed against a black background to produce a one-off finished picture known as a glass collodion positive, or, more commonly, an ambrotype.

Despite its complications the process was taken up with enthusiasm in the field as well as in the studio, and portable wet-collodion darkrooms were carried all over the world by a whole generation of early landscape and documentary photographers. Roger Fenton went to the Crimea with a horse-

drawn van and two assistants, while Auguste Bisson ascended Mont Blanc with 25 porters to carry his equipment. It is to such pioneers and to Archer's process that we owe the pictorial records of such events as the Madras famine, the Paris Commune and the American Civil War, and the first images of places as various as the Pyramids, the Yosemite Valley and the Great Wall of China.

Amateurs, too, used the method, and one of them, C. L. Dodgson ('Lewis Carroll'), commented on it in his parody of Longfellow's *Song of Hiawatha*:

> First a piece of glass he coated,
> With collodion, and plunged it
> In a bath of lunar caustic
> Carefully dissolved in water -
> There he left it certain minutes.
> Secondly my Hiawatha
> Made with cunning hand a mixture
> Of the acid pyrogallic,
> And of glacial acetic
> And of alcohol and water.

Dodgson made fun of the process, but he used it with enthusiasm.

Egg Whites and After

Albumen paper — the standard printing paper for use with wet collodion negatives — was introduced by Blanquart Everard in 1850. Paper with an albumen coating was treated with salt and silver nitrate, and then exposed beneath a glass negative until the picture appeared. The majority of prints made between 1850 and 1890 were made on albumen paper from wet-collodion negatives. By 1866 it was estimated that in Britain alone six million egg whites a year were being used in the preparation of photographic paper, and as late as 1894 a firm in Dresden, Europe's largest producer of albumen paper, was using up some six thousand eggs a day.

Because albumen prints had a tendency to become yellow and fade, other printing processes were sought and found. Sir Joseph Wilson Swan introduced carbon prints in 1864, and the same decade saw the development of W. B. Woodbury's 'Woodburytype', a process that came to be used widely

for pasted-in book illustrations in the 1870s. Both processes achieved greater permanence of pigment, and both met with some success, but neither made the same impact as the popular albumen print. The carbon print, however, did grow to claim a useful share of the market.

The first natural colour photograph was produced by James Clark Maxwell in 1861, but more than thirty years were to pass before effective use was made of his method, and many more before colour was to become a regular feature of family photographs.

Eventually though, in the 1890s, albumen paper was superseded by gelatin-chloride printing-out papers, which were faster to react, cheaper to buy and far less liable to fading. The day of the egg white was over, but not before it had dominated photographic printing for forty years.

The Rise of the Professional Photographer
London's first professional studio was opened by Richard Beard, the improver of the daguerreotype, in the early 1840s, and other daguerreotype photographers quickly followed. There was no comparable growth in calotype studios, for licensees of the process were few, and a minority of those who practised it sought to make their living by it.

The primary requirement of the early studios was light, and large areas of window were a common feature. These windows generally faced north to avoid the unflattering effects that direct sunlight can produce, such as shadows beneath the nose. In winter or in poor weather opening hours were likely to be curtailed. Not surprisingly, studios were often set up on the top floor of the premises or in a glasshouse on the roof. In rooftop studios the subject might be placed in a chair set on a revolving platform that could be turned as the day wore on, to make the most of the changing light. Blue-tinted glass was often used in such studios, since it reduced the glare for the subject, whilst having no adverse effects on the end product.

That the sitters should so often appear stiff and unsmiling is not difficult to understand, since they were required to sit perfectly still, helped perhaps by a head-clamp or brace, for one or two long minutes. Let those who think two minutes short try sitting motionless for that time, blinking as little as possible and trying to maintain a natural expression. (It should, though, be added that solemnity was in accord with Victorian ideas of self-worth, and it

remained normal in photographs even when exposure times became very much shorter.)

Whilst the daguerreotypes gained great popularity amongst those who could afford them, it was the patent-free wet-collodion process that made possible the real rise, in the 1850s, of the commercial photographer. Even more important was the boost given by the introduction of the carte de visite in the mid-fifties. This visiting-card-sized photograph became a craze (for crazes are nothing new). Once royalty had patronised a carte photographer, the demand became immense and the price dropped. Before the introduction of the carte, photographic portraits could cost two or three pounds, which was twice the weekly income of many ordinary families. The carte arrived on the scene at half-a-crown and soon dropped to a shilling. Suddenly photographs were within the range of the common man and not just an indulgence of the portrait-painted classes.

So professional photography boomed. Photographers set up in every town, and some towns had many. Glasshouse Street, just off Piccadilly Circus, is said to have gained its name from the large number of photographic studios in the area. The 1851 census showed 51 commercial photographers in the country; by 1861 the number had risen to 2,534. Photographs had become a necessity.

With the increase in practitioners there may have come something of a fall in standards. Certainly, some East End photographers (as described by Henry Mayhew, in his investigation of Victorian London) seem to have produced pictures that were as unrecognisable as they were unappealing. Many small and provincial studios, however, were run by perfectly competent professionals. Perhaps popularisation led to some degree of vulgarisation, but without that popularisation few of us would now possess likenesses of our Victorian forebears. Perhaps, too, the average professional, though able, was uninspired and inclined to follow the conventions of the day. But it is such routine conformity that often helps us, now, in the matter of dating photographs.

One passing titbit of improbable information deserves a mention. Victorian photographers, when shorter exposures became possible, apparently encouraged ladies to say not 'cheese' but 'prunes'. Presumably the choice of word was designed to produce on the sitter's face a not

unattractive moue. When one examines photographs of the time, however, it has to be admitted that the incidence of not unattractive moues is by no means high.

Dry Plates

The inconvenience of wet collodion left much room for improvement, and the need was for a dry plate process. Yet, paradoxically, the popularity of wet collodion meant that a new method would not easily catch on.

In fact, a new process emerged in 1855 and by 1860 dry plates were on sale in England. They failed, however, to make a major impact. Not until 1871, when Dr Richard Leach Maddox of Southampton published his method of preparing gelatin dry plates, did a shift in loyalties begin. By 1873 John Burgess was marketing the new plates, but even then the change was slow. Dry plates were more expensive at first, since, unlike wet collodion plates, they could not be scraped clean and re-used. As the seventies progressed, however, Maddox's process began to establish itself more firmly.

Maddox had developed a coating which was compounded of cadmium bromide, silver nitrate and gelatin, and which retained its sensitivity to light when dry. As well as being easier to use, his plates were kinder to cameras, the materials of which tended to rot when in frequent contact with the damp and sticky collodion coatings. The new plates were factory made, were easy to store, and did not have to be prepared in the field. These features all allowed greater mobility to the outdoor photographer.

Perhaps the decisive factor in the shift to new methods was a discovery in 1878 by Charles Bennett. He showed that leaving the emulsion to brew for a day or two at 90° Fahrenheit, before spreading it on the plate, led to greatly increased light sensitivity. Suddenly it was possible to take photographs with exposures of as little as one twenty-fifth of a second.

This development speeded up the change in standard practice, and by 1885 wet collodion was obsolete. With it went all the equipment needed for on-the-spot treatment of plates. Photography had gained enormously in convenience, and the age of the snapshot was just around the corner.

The Arrival of Celluloid

Further improvements in photography now needed a lighter and more flexible film base to replace the weighty and fragile glass. Celluloid had in fact been invented in 1861 by Alexander Parkes, but it was not at first made in the clear, thin and flexible sheets that would render it suitable for photographic use. In 1888 John Carbutt of Philadelphia began to produce celluloid in such a form. What was then required was somebody to see its possibilities as a film base.

George Eastman was to be that man. He had already, in 1885, invented a form of gelatin-coated, paper-backed film, which could be used in a roll in a specially designed camera, and from which the paper could be discarded when the film was ready for processing. He designed a purpose-built box camera in which to use the film and began to market this in 1888 as the No. 1 Kodak. The name 'Kodak', incidentally, had no specific connotations; like the camera that it identified, it was invented for international use. The Kodak took circular pictures, 2½" in diameter, about a hundred to a roll. The secret of Eastman's success lay in what happened when all the frames had been exposed. The film was sealed in the camera, and the customer had simply to return the entire apparatus to the Eastman factory, where the film was removed and processed. The company then returned the camera, reloaded and ready for use, together with the set of prints. Eastman's slogan, 'You press the button and we do the rest', summed up the procedure perfectly. Success was immediate. The camera was easy to use and quickly became popular.

But further developments were to come, which were to help the Eastman company to become the biggest photographic firm in the world. By 1890 Eastman had realised the possibilities of celluloid, and he shifted to this material for his films, producing rolls capable of giving a more manageable 12 or 24 prints. One hundred prints to a film may seem like good value, but it takes a long time before the results of the earlier exposures can be enjoyed, and photographers have never been great believers in deferred gratification. Eastman went on, in 1895, to introduce a black paper packaging, which facilitated loading and unloading outside a darkened room. Then, in 1900, came the greatest step of all towards the popularisation of photography, the box Brownie, and the Victorian age ended as the age of the snapshot began.

Identifying Early Photographs

Whilst many variations of photographic process and products were tried during the 19th century, the kinds of photograph most likely to be encountered today are relatively few, and usually a fair attempt can be made to identify which they are. For this, some knowledge of the characteristics of each type is needed, and this often includes an awareness of the ways in which different kinds of photograph have deteriorated. Where dimensions are given, they are stated first in inches, since that is how old photographs were measured. Metric equivalents are then given, but are approximate.

The Earliest Examples

Daguerreotypes and calotypes are the least likely kinds of photograph to be found in the family archive, since they date from before the major boom in commercial photography. Both processes were relatively expensive, and both had their share of failures. At first the long exposure times meant that neither was thought of as particularly suitable for portraiture. Soon, though, exposure times were reduced, and daguerreotype portrait studios were opened up. Calotype photographers never really explored the commercial market, though of their number Hill and Adamson must still rank amongst the great portrait photographers, and lucky are any family historians whose ancestors were among their Edinburgh gentry or Newhaven fisherfolk subjects. Compared to the later users of the wet collodion process, practitioners of both daguerreotype and calotype were few; statistically, however, there has to be a far greater chance of inheriting a daguerreotype than a calotype.

The daguerreotype was much admired for its precision of detail, though the image was faint, and the highly polished, mirror-like surface made it impossible to view from all angles. Since the daguerreotype is essentially a negative, the image is reversed, as an examination of buttoned garments may show. It may be evident that the coating is of silver, but a golden toning is also quite likely, for the image was often treated with a solution of gold salt to soften the cold, metallic look. There is also a possibility of the metal being

tarnished with a bluish tinge, especially around the edges of the picture. But the presence of the negative image and the highly reflective surface are the features by which a daguerreotype may be most easily recognised. The surface is also very delicate, so the slightest abrasions leave their mark, and scratches are very characteristic of these pictures.

Since the surface is so vulnerable, it is usually protected by glass and is often presented in a small frame or case, such as had previously been used for miniature paintings. The cases are often of leather, opening like a book, with a velvet lining facing the picture.

The calotype was capable of much more subtle tonal effects but was likely to be less sharply defined. A calotype was printed on paper from a paper negative, and the fact that the negative was a fibrous substance means that the end product may have a grainy quality, with poor reproduction of fine detail. As a rough guide, calotype portraits are most likely to measure between 4 and 5 inches (about 10-13 cm) one way and 6-7 inches (15-18 cm) the other. The surface is matt, with a very faint sheen. The colour is reddish brown or sepia, but fading is very likely, especially at the edges, when the result is a yellowish colour. Finally, it should again be emphasised that calotypes are rare.

Ambrotypes

Ambrotypes — wet collodion negatives turned into one-off positives — have something of the elegance and quality of daguerreotypes. But they were cheaper to produce, coincided with the rise of the commercial photographer, and have therefore come down to us in much greater numbers.

The ambrotype was devised by Scott Archer in collaboration with Peter Fry. It took for its starting point a thin, underexposed glass negative, which was then chemically bleached. The resulting pale image on clear glass was given a backing of black velvet or black shellac. The result of this, when viewed from the unmasked side, was to turn the clear glass areas black. Against this black background the exposed and bleached parts of the negative, though darker than clear glass, were silvery and reflected the light. Thus a positive effect was achieved, even though the highlights tended more towards grey than white.

These pictures were originally referred to in Britain as collodion positives, but they were patented in the United States under the name of ambrotype, which is how they soon came to be generally known.

An ambrotype has those features that are characteristic of wet collodion pictures in general: the image is sharp and clear, and more reminiscent of the daguerreotype than the calotype. There may, though, as already indicated, be a dullness about the highlights. Whereas with a daguerreotype it is necessary to find the right angle for viewing, no such difficulty is presented by the ambrotype. On the other hand, when the picture is moved about in relation to the light, it is sometimes possible to find a point at which a negative effect is created.

It was common to touch up details of an ambrotype with a hint of colour for lips or cheeks, or with a spot of gilding for such items as buttons, jewellery and watch chains. These cosmetic refinements may still often be found, though the colouring may well have faded somewhat with the passage of time.

If the black backing has been applied to the emulsion side of the plate, then one views the picture from the back of the original negative and, as on a positive, such things as buttoned garments appear the right way round. If this has been done, in theory no additional glass is needed at the front of the picture, since the thickness of the plate provides its own protection. In practice, however, a sheet of protective glass seems generally to have been included in frames and cases, whichever side of the original is black-backed. If the black backing is on the untreated side of the negative, it allows a clearer image but the picture is reversed. In such cases, too, it is often possible to see the white parts of the picture standing out a little from the dark parts, because the thickness of the plate separates the pale emulsion from the black backing.

Although sizes up to full plate (6½ x 8½ inches, or 16.5 x 21.5 cm) are possible for ambrotypes, they are generally considerably smaller, with 2¼ x 3¼ inches (5.5 x 8 cm) being quite common.

Certain signs of deterioration are diagnostic features when it comes to identifying ambrotypes. The black shellac backing, which seems to have been much more commonly used than velvet, has proved liable to crazing and flaking. Sometimes small areas of shellac have fallen away to leave patches of

clear glass; sometimes a mosaic pattern of white cracks can be seen in the darker areas of the picture. A further kind of deterioration is the result of moisture invasion between the layers of the packaged end product, and this can show itself, especially near the edges, as small mould growths or water ring-marks.

Like daguerrotypes, ambrotypes are frequently found framed or cased, and since cases in general (and one type of case in particular) are so often associated with ambrotypes, it is appropriate to consider their packaging. A sandwich was generally made of picture and protective glass, perhaps with a thin metal matt or decorative border between, and this was bound around the edges with a thin strip of paper or tape, to inhibit moisture invasion. The sandwich was then fitted into a thin metal mount or frame, and this in turn was fitted into one side of a hinged case. The other face of the opened case commonly held a plush velvet lining, but a second, companion picture was also a possibility.

The metal used for early matts and frames was often brass, but during the ambrotype period pinchbeck was generally used. This was a soft, brass-like, gold-coloured alloy that was produced in thin sheets which could be cut to size, and from which the holes in frames could be stamped out. The overlapping edges of pinchbeck frames could be folded over the edges of the glass behind.

The case itself, during the daguerreotype period, was most frequently of leather, but for the less expensive ambrotypes cheaper materials came into use, and wood, paper, papier mâché and leather-cloth were all tried. One particular material, however, tends to be associated with ambrotype cases, and that is thermoplastic. In 1854 Samuel Rich patented the Union Case, made of a plastic material compounded of shellac and sawdust. This American invention was, in fact, the first commercial use of plastic. Because the thermoplastic was capable of being moulded, it could be used to make highly decorated products, and by the 1860s very ornate Union Cases were produced, decorated with flowers, fruits, scrolls, swags and even bas-relief pictures. The Union Case came to be particularly associated with ambrotypes. Because of the date of its introduction, it is tempting to assert that if a picture is in a Union Case, it cannot be a daguerreotype, but there is always the possibility of an early photograph being later transferred to a case of a more recent date.

Cartes de Visite

Whilst there is some dispute about the originator of cartes de visite, there seems little doubt about who first popularised them. In 1853 André Disderi, a Parisian photographer, began making several small exposures on one large photographic plate. The practice did not catch on at first until, so the story goes, Napoleon III stopped off at Disderi's studio, when leading his troops to war with Austria, in order to have his likeness taken. This show of imperial approval led to a quick and lively interest in Disderi and his photographs. In Britain a similar boost was given to the new size of photographs when Queen Victoria and Prince Albert permitted John Mayall to photograph them in carte format at Buckingham Palace. The resulting portraits were published in book form, but it was as individual cartes that they found an eager and enormous market. Everybody wanted cartes of the royal family and, soon, of famous people generally. Not only that — everybody wanted to appear on cartes themselves.

There may at first have been some thought that they could be used as illustrated calling cards, but the cartes quickly became desirable objects in their own right. People began to collect them, snapping up likenesses of celebrities and swapping pictures with their friends. The craze was known as cartomania. There is, incidentally, a note of warning to be sounded here for family historians. The appearance of a nationally or locally eminent Victorian or two in a family collection of cartes does not necessarily imply any kinship or even acquaintance. They are no more likely to be relations than are the cut-out magazine posters of popular entertainers stuck on the bedroom walls of today's young.

As the craze developed, specially produced albums were created for keeping the pictures in, with carte-sized apertures ready and waiting. The albums could then be displayed to friends and relations and were, in effect, the coffee table books of their age. It is to the carte that we owe the invaluable institution of the family album.

Once the idea of cartes was firmly taken up, special cameras were produced, generally designed to take eight pictures on a single plate. Some had a simple lens, taking a series of shots on a plate that was shifted into a new position between exposures. Others had multiple lenses that operated simultaneously. Still others had multiple lenses, but took pictures one after

another. The survival of two identical prints does not, of course, have to mean that a simultaneous exposure camera was used, since negatives allowed as many copies to be made from a picture as were needed.

The identification of cartes is simple. The paper picture, normally an albumen print, measures about 3½ x 2¼ inches (9 x 6 cm). It is brought to a size of about 4 x 2½ inches (10 x 6.5 cm) by being pasted on a slightly larger photographer's trade card, which usually bears his or her name and address and often carries additional advertising matter. The complete item is about the size of the visiting card from which it derives its name. The only type of photograph that could be confused with a carte is the tintype, since this was sometimes made up to the same finished size so that it could be included in the standard albums. Of tintypes more will be said in due course.

Cabinet Prints

Although cartes continued to be popular until the end of the 19th century, sales dropped off from the enormous and unsustainable peak of the early 1860s. To counter this a new and larger size of popular portrait – the cabinet print – was introduced in 1866. Though they never reached the heights of success achieved by their smaller relations in the days of cartomania, the cabinet prints proved and remained very popular, and many of them survive.

As cabinet prints took over a large corner of the portrait market, photographic albums were produced with spaces of the right size to house them (or, more usually, with some spaces of cabinet size and some of carte size).

Like cartes, cabinet prints are easy to identify. The recipe is the same, but on a larger scale: a paper print is pasted on a slightly larger photographer's card. The size of prints varies a little but is generally around 4 x 5½ inches (10 x 14 cm) and the finished item comes to about 4½ x 6½ inches (11.5 x 16.5 cm). Albumen prints are the most usual, at least until the later years of the century, though carbon prints are quite frequently found, and platinum prints are not unknown.

Printing Processes

It seems unreasonable to mention printing processes without saying anything about them. Albumen paper, in particular, deserves some attention,

since it was in such common use for both cartes de visite and cabinet prints. But though many different processes were tried in Victorian times, descriptions of their results are not always illuminating. Descriptions so often have to depend largely on colour, and the perception of colour is highly subjective. Different kinds of print have been variously referred to as reddish brown, warm brown, sepia, rich brown, dark brown, chocolate brown and blackish brown. Unfortunately, one man's reddish brown is another man's sepia. Or even the same man's sepia. So although colour is about to be mentioned with reference to processes, the shortcomings of such descriptions are readily acknowledged.

The albumen print, which caused such a huge consumption of egg whites, is smooth surfaced and slightly glossy in its finish. It is fragile and easily creased, which is why pasting it to a piece of stout card was such a suitable practice. Its natural colour is sepia, but there is a yellowish tone, which becomes very pronounced as the print fades, and which was considered unattractive. The prints were often, therefore, treated with gold chloride to give a richer tone – which is often referred to as plum coloured. This treatment also increased the 'permanence' of the image. But, for purposes of identification, it is the discolouring tendency that remains most helpful: the highlights are likely to be more yellow than white.

For better quality cartes and cabinets, the carbon print was sometimes used. This process was introduced in 1864 and was still being used until about 1930. It gave strong, rich colours and good gradation of tones. As well as the usual sepia range, carbon printing could produce results that were black, blue, green and chalk red. There, at least, are some colours which leave little room for argument, and which may serve to identify some carbon prints. For those in the brown/sepia range (and they form the vast majority) the problem remains. But there really is a characteristically dense intensity to the darkest tones. Further help in identification can be gained from the fact that carbon prints, when viewed at an angle, have a slight relief effect, almost as if the image has been painted on. As well as being used on some cartes and cabinets, carbon printing is often found on photographs made on materials other than paper, and most prints on a non-paper base made between about 1870 and 1915 were produced by this process.

Carbon printing was one of a group of techniques that, in the search for longer-lasting pictures, formed an image by hardening chemicals to the light, rather than simply darkening them. Another member of this family of processes was the chromotype. Introduced in the mid-1870s, chromotypes won some adherents among ambitious photographers who were prepared to accept the expense and practical difficulties involved. They are characterised by a very smooth, hard surface and by fine detail and good contrasts. The photographers details are incorporated with the image as part of the photograph itself, and this covers the whole of the front. The name of the process is also commonly included on the face of the print.

One final printing process that may be reasonably easily recognised, and that had its adherents in the last two decades of the century, is the platinum print (or platinotype). The paper was impregnated, rather than merely coated, with sensitised platinum salts, and this brought resistance to fading. Pictures were produced in both grey and sepia, and had a full and subtle range of tones. Because one becomes so accustomed to old photographs in shades of brown, the grey examples, with their delicate gradations of tone, are now particularly striking. The totally non-reflective matt surface is a further help to identification, and mention of the process on the mount is not unknown.

Tintypes

Cheapest of all portraits was the tintype, or ferrotype as it was more properly if less popularly called, since the photographic plate was a small piece of iron. The process was patented by an American, Hamilton L. Smith, in the mid 1850s, and involved coating a thin, blackened sheet of iron with a wet collodion emulsion. The system was developed for the use of the itinerant photographer, with all the chemical operations taking place inside a specially designed camera. The cameras were multi-lensed and some could give up to 36 exposures on one plate. The plate was processed quickly, taken from the camera, cut up into individual tintypes and handed, still wet, to the customer. The cost was only a few pence and the result, as with daguerreotypes and ambrotypes, was a unique picture. The quality, however, was much inferior.

At their simplest, tintypes can be recognised from the fact that they are on a thin, sharp-edged piece of metal, but this fact may be disguised by a frame or mount, for tintypes, like other one-off portraits, were often encased.

But a cheaper quality of presentation is often evident. This may be seen both in the papery materials of the outer casing, if there is one, and in the pinchbeck, which may appear thin and roughly cut. Some tintypes survive in the form of glass and iron sandwich, held together by the folded-over edges of the pinchbeck frame. In these cases, the metal back can be clearly seen.

If the back is hidden but the picture's surface is not covered by glass, a light tap with the back of the fingernail will demonstrate that it is not a paper print, (though whether such treatment of old pictures can be responsibly recommended is another question). But doubts can perhaps be more wisely resolved by holding a weak magnet against the paper or card backing. It will attract a tintype but not a daguerreotype, ambrotype or paper print. Something like a fridge magnet is strong enough to make the point, without clinging so firmly as to cause any damage when pulled away.

The image is reversed and likely to be of poor quality. Though some examples have good contrast, many have a murky appearance, for black and the darker shades of grey were what the tintype was really good at. In theory the picture can be of any size, but small examples predominate, since most tintypes are merely snipped-off fractions of a whole plate. Many measure no more than 1½ x 2½ inches (3.5 x 6.5 cm), though the pictures were often slipped into a card and paper mount to bring them up to carte size for insertion into an album. One popular variation was the gem tintype, the smallest portrait that was commercially produced. This measured a mere 1 x ½ inch (2.5 x 1.5 cm) and was either mounted in the cut-out space of a carte-sized mount or kept in a locket or brooch.

Sometimes the metal seems to have been very thinly coated, so that the emulsion has by now worn down in places to the bare metal. Such examples are particularly vulnerable to scratching. Other tintypes seem to have been more thickly coated, but this can result in bubbles (or popped bubbles) on the surface, and in tiny wrinkles that may sometimes be the result of the picture having been touched before it was properly dry. Another sign of deterioration that immediately identifies a tintype is rust – either on the metal itself, or staining the card or paper of a mount.

It is easy to disparage the humble tintype. In Britain, its status reflected its cost. The fact remains, however, that it extended still further the range of

classes covered by early photography, and people who were also photographed by other methods can be presented by tintypes in a different setting. Since the tintype was very much the province of the travelling photographer, it can show our ancestors away from the formality of a studio, as they appeared, say, on a day's outing at the seaside or at the fair. It is also worth noticing that, in the United States, the tintype acquired no such social associations, but occupied a niche in the mainstream of the photographic market.

Novelties

From time to time various new sizes or materials enjoyed a degree of popularity, though none can be considered a major milestone in the history of photography.

Often the novelty lay in shape and size. Such pictures are often rectangles of a more elongated kind than usual, and they can sometimes be recognised from their measurements. Promenade Prints, measuring 7 x 4 inches (18 x 10 cm) were introduced in 1875; Boudoir Prints, of uncertain date, were 8½ x 5¼ inches (21.5 x 13.5 cm). But many such unconventional formats turn out to be products of the early 20th century, when attempts were made to fill the gap that was being left by the decline of cartes and cabinet prints. None of these novelties caught the public imagination to the extent that the earlier formats had, and few of them of them are likely to be found in a family collection.

Tintypes are sometimes found as circular exposures, though the metal on which they are printed is cut up into conventional rectangular pieces. But it was also possible to give standard examples the appearance of a round or oval picture by mounting them in the shaped aperture of a card mount designed to fit into an album.

Photographs incorporated into jewellery, especially lockets, were popular in both Victorian and Edwardian times, and these were often hand-tinted. Some jewellery photographs are gem tintypes, but many are small paper prints cut down to the right size and shape.

Non-standard materials were also tried as the photographic base. Portraits on porcelain and glassware were popular in the later nineteenth and early twentieth centuries, and pictures on enamel plaques were in some favour

from 1880 until after the First World War. Cloth and wood were also used, but these were often for subjects other than people.

Of the novelty materials used for portraiture, opal glass is particularly attractive. Such pictures were valued and produced in some numbers from 1865 until about the turn of the century. Various processes were used, of which carbon printing was the most common, especially in the later years. These photographs are liable to be of cabinet print size or larger. If they are framed, they may be identified by the white, opalescent appearance of the background and probably by the characteristics, already mentioned, of a carbon print. If they are unframed, the white translucent glass is, of course, easy to recognise. Whilst the image itself may have stood up well to the passage of time, the glass may have taken on a yellowish or buff mottling.

Roll Film Pictures

Very early forms of roll film were made of oiled, sensitised paper or gelatin emulsion, with a paper backing from which it was later stripped off for processing. But it was with celluloid roll film that snapshot photography really took off, and with the Box Brownie, in the Edwardian period, that it became fully the activity of Everyman. Thus, whilst some roll film pictures date from the last years of the nineteenth century, they are the products of relatively few dedicated amateurs. In most collections, therefore, we may reasonably think of roll film photographs as a twentieth century phenomenon. But if there was serious enthusiast in the family, his or her presence may be revealed by the survival of some of the circular pictures, 2½ inches (6.5 cm) in diameter, which were produced by the very earliest Kodaks.

Stereos

Stereoscopic photos, which, when looked at through a suitable viewer, gave the illusion of three dimensions, were perhaps photography's first craze — though not one which reached the same proportions as cartomania. The very earliest of these pictures were produced by the daguerreotype process, but their first peak of popularity came in the 1850s and 1860s. Though they were rather eclipsed by the carte de visite, they enjoyed periodic revivals of popularity well into the next century. By about 1860 almost every middle-

class Victorian household had a stereoscope and a collection of accompanying photographs, and an industry emerged to cater for their taste. The London Stereoscopic Company was one of the most successful firms to enter the market, and in the early 1860s, at the height of the craze, it boasted a publications list of some hundred thousand subjects.

The effect obtained by looking simultaneously at two pictures, representing the same scene from slightly differing viewpoints, had been discovered by Sir Charles Wheatstone before the age of photography. Photography was able to use this effect by means of a camera fitted with two lenses, which were placed the same distance apart as the human eyes.

Each eye, having its own field of vision, registers a slightly different scene. This may be simply ascertained by closing first one eye and then the other. When these two scenes are viewed at the same time, that is to say, when both eyes are open, we see in three dimensions, judging not only breadth and height, but also the distance any object or part of an object is from the eyes. When we open both eyes, the effect may not immediately seem more three-dimensional than when we just open one, but a simple experiment will show that it is indeed on binocular vision that we rely for our judgement of depth or distance. Scatter a number of small coins on a table at about arm's length. Close one eye, decide on a coin, and place the end of a forefinger quickly over the centre of it. Try this a few times, changing hands and eyes, and moving the position of the coins frequently to prevent memory from compensating for any uncertainty of judgement. Because the items are so very close, most attempts may be successful, but there will probably be a few near misses. Now repeat the procedure with both eyes open. The success rate in placing a finger-tip unhesitatingly on the centre of the chosen coin will probably be greater. The difference between the monocular and binocular attempts may be small, since the objects are so near. But the test is nevertheless very likely to demonstrate that the accuracy of three-dimensional vision depends on two eyes seeing almost, but not quite, the same thing.

What the eyes achieve naturally, the stereoscope imitates. When we use a viewer to look at the two slightly different stereo images side by side, simultaneously but independently, with the right eye seeing one picture and the left eye seeing the other, we recreate that divergence between images seen in real life by each eye.

It may at first seem that consideration of stereo pictures is of little interest to the family historian. Though pictures of people exist, stereos were not primarily or even significantly a medium for portraits. Pictures with greater depth, where people, if included at all, are set against a background, were considered more appropriate for making the most of the stereoscopic effect. The chances, therefore, of finding a stereo picture of an ancestor are minimal. If inherited stereos are of interest, it may only be as family heirlooms. But there is the possibility that some of the scenes depicted are of significance. All manner of subjects were photographed, often taken as a series and sold as sets. There were natural history pictures, photographs of foot and paw prints to aid trackers, anatomical series showing skulls and the structure of the eye, and medical series featuring interesting prostheses. There were anecdotal pictures, stage-managed to tell a story or point a moral, and resembling stills from films. There were nude studies, which was one kind of portraiture where the three-dimensional effect might be considered of interest. But more than anything else, there were places: buildings of London, scenes along the Thames, famous cities, the sights of Russia. With stereoscopes our ancestors travelled the world. Many of these scenes were part of sets. But local pictures can also be found — the church, the town hall, the High Street — and certainly any inherited collection of cards should be checked for scenes that their owners were familiar with. Thus (though in a more modest way) stereos can have much the same sort of interest as topographical postcards for the historian who wishes to see the family in a context.

There is, of course, no difficulty in identifying stereos. They consist of two nearly identical pictures side by side. A few are daguerreotypes, but most are paper prints, often albumen prints pasted on cards. These were viewed by reflected light. Some stereos are found on glass, and some on tissue inserted into holes in card. These types would be slotted into the open end of a viewer, and were thus lit from behind by transmitted light.

The size of stereos varies, but the cards for the most popular type of viewer measure about 7 x 3½ inches (18 x 9 cm), containing two pictures that are each about 3 inches (7.5 cm) square.

Finally, since it is quite possible to inherit pictures without the accompanying viewer, mention might be made of a way of viewing the cards without a stereoscope. It sometimes works. Take a piece of card, a postcard

say, and hold it sideways on between face and stereo picture, so that one edge of the postcard divides the two images and the other edge touches the vertical line through nose to forehead. Thus each eye can see only one image. Then let the eyes settle down and try to work out the message they are receiving. If unsuccessful, try a longer or a shorter piece of card, since the main problem is finding the correct distance the pictures have to be from the eyes. This method may produce results. But since there may initially be a degree of visual discomfort, and since it is in all probability a dreadfully unhealthy way to treat one's eyes, it should be emphasised that the method is described rather than recommended.

Other Photographic Items

As well as photographs themselves, other photographic items may have been passed down to the researcher. Their market value may be low, but their value as ancestral objects and as attractive artefacts may be considerable. Though any lengthy discussion of such items is beyond the scope of this work, some passing mention of the most common seems appropriate.

Cameras

Whilst an earlier heirloom is possible, camera-owning became a reality for the population at large in the late 1880s and the 1890s with the proliferation of hand-held models. Even then, cameras were for the devotee rather than the casual owner, since the processing industry had yet to emerge. But there were people who could afford the money, time and effort involved in photography, and their numbers were sufficient to make them worth catering for.

As well as highly portable cameras of a conventional type, the last years of the nineteenth century saw a rash of novelties spring up: cameras were designed to look like postal packages or handbags, or made to be concealed in the hat or, with a lens peeping through a button-hole, in the waistcoat. In Russia the Tsar's secret police made use (or, at least, ordered a consignment) of cameras masquerading as pocket watches. But the craze for camouflaged cameras, never very serious, had largely died out by 1900, and surviving family cameras are more likely to date from the twentieth century and the Brownie revolution.

Albums

Cartomania created a need for storage and display, and thus the family album was born. Albums were produced for cartes and, before long, for cabinet prints or a mixture of the two. They formed both a pictorial family archive and a source of entertainment and conversation.

Pages were made of thick card, for they had to accommodate two pictures slotted back-to-back into each cut-out space provided. The pages might be plain, but in larger albums a proportion of them were often decorated with

illustrations. Flowers were very popular, as were waterside scenes, while snowscapes, swallows, swans, cornfields and romantic ruins all made their appearance. The better pictures were delicately done and have a distinct charm.

If the pages could be pretty, the bindings could be sumptuous. Leather was common, was generally padded, and could be heavily embossed or gilded. Some albums had mother-of-pearl or ivory set in, and some incorporated a musical movement. Many were fastened with a metal clasp, and metal might also be used to protect the corners. The modern owner of a family album may well possess a very attractive volume, quite apart from the interest and appeal of its contents.

Stereoscopes

Like the family album, the stereoscope became a standard item of entertainment in many Victorian homes. Of the various kinds that were produced, the one that had widest use was that invented by the American writer, Oliver Wendell Holmes. Designed in 1860, Holmes' stereoscope continued in use – with small modifications over the years – well into the twentieth century. It was less awkward to handle than some earlier kinds and it was cheap to produce. Because of its success, it is the kind of viewer most likely to be discovered amongst family memorabilia.

Holmes' stereoscope was a mask-like structure held before the eyes by a handle protruding below, rather like a cumbersome lorgnette. A flat runner stuck out in front of the mask. On this was a crosspiece that had supports to hold the card and that could be slid backwards or forwards along the runner until the picture, viewed through the eyeholes of the mask, came into focus. More luxurious models were mounted on a stand rather than held by a handle.

If a stereoscope has been handed down without accompanying photographs, it is worth looking out for some at collectors' fairs. The pictures would not be of family significance but the stereoscope would be used again, and there is something satisfying about old objects continuing to serve their purpose. If buying stereo cards, it is worth making sure that they will fit one's viewer. (Some people have a good eye for sizes; others carry a tape measure.)

Frames

Fairly ornate frames started to appear early in the history of photography. Carved wooden frames with plaster mouldings were used as early as the 1840s to display daguerreotypes on a wall. Frames in all manner of designs and materials survive, of which the most attractive (and often the most valuable) are those in the art nouveau style. Pointers towards dating frames would be of dubious assistance, since there is no reason to assume that a frame and its contents are contemporaneous. Photographs about the house today are not necessarily in frames of the same age, and we should not expect our forefathers to show any greater concern in the matter than we show ourselves.

Of the hinged case, used as a portable frame for daguerreotypes, ambrotypes or even tintypes with delusions of grandeur, something has already been said. It might be added that the same basic style – with pinchbeck surround and an outer housing of leather, papier-mâché or thermoplastic – was also frequently used for small open frames with no folding cover.

One further point that might be made about frames is that things are often other than they seem. Just as all that glisters is not gold, so all that bears a grain is not wood. Plaster, cardboard or papier-mâché, could be painted or covered in paper with a wood or leather effect, and grain may derive from a brush rather than from growth rings.

Negatives

Of glass negatives, the gelatin dry-plates would seem the more likely to be encountered today, since they are more recent, and since the earlier wet collodion plates were commonly stripped and recycled. Nevertheless, wet collodion plates have survived. Identification may not be easy, but the wet plates may prove to be more unevenly coated at the edges: the coating was an individual, on-the-spot process and often had to be hurried. There is even the chance of a thumb-sized, uncoated corner being found, where the plate, like the heel of the baby Achilles, was held during treatment. 1880 is a rough watershed date to mark the change from wet to dry negatives.

Dry-plate negatives, though, are much more likely to be encountered. They could be prepared in advance, so factory production was possible, and that brought a degree of quality control and a more evenly coated product.

Whatever kind of negative has been passed down, whether glass or the earliest celluloid variety, the obvious thing to do is to make a print from it. Photographic chemicals and paper are not cheap, but simple contact prints can be made without the expense of an enlarger. The owner of an enlarger is likely, in fact, to find the machine unable to cope with anything other than modern film sizes. But older negatives are usually of dimensions sufficient to make a contact print worth having.

Dating the Artefact

Family historians often need to try to assign a date to pictures they have acquired. Sometimes a date can help us establish which member of a family is pictured. Sometimes the subject's identity is known, but the age can be very difficult to establish, since in old photographs the young can often look very middle-aged and the middle-aged can look old. An idea of the picture's date can help the descendants decide which period of life has been captured.

Various kinds of evidence can be considered in trying to date a photograph: there is the type of photograph, there are aspects of the finished product other than the image, and there is the picture itself. That picture can contain clues in the background and props, in the composition and technique, and in the clothes worn by the sitter. This and the next two sections deal with the kinds of clue that can help in this process of dating. Summaries, in table form for quick reference, are provided later in the book.

It should be pointed out that a period of time rather than a precise year is often the best that can be hoped for, and an earliest possible date is more likely to be established than a later limit.

Types of Photograph - Formats and Processes

Once the type of photograph has been identified, that in itself can give a start to the business of dating, since the date of introduction and the period of popularity of a process are generally known. The details here are, in part, a drawing together of information already touched on, but additional material is also included.

Calotypes and Daguerreotypes

Examples of either of these processes are likely to date from the 1840s. From 1851 onwards they were quickly replaced by the wet collodion process, and both had largely disappeared by the mid 1850s. There were, though, some professional daguerreotypists who were reluctant to make the change to collodion, and who resisted it for much of the decade. Even later examples originate from the United States, where the daguerreotype retained some hold on the market well into the 1860s.

Ambrotypes

Ambrotypes had a fairly short life, corresponding more or less with the third quarter of the nineteenth century. First introduced in the very early 1850s (authorities seem divided between 1851 and 1852), they had become rather uncommon by about 1880, though later examples are not impossible. Those in Union Cases are not earlier than 1854, unless they have been re-cased, and the more ornate the decoration on the case, the later it is likely to be.

The quality of both image and casing varied enormously, and some help may be gleaned from this fact. Though not to be relied on as a dating principle, the generalisation that ambrotype standards deteriorated over the years may at least give some rough guidance. Well-framed pictures with good contrasts and strong highlights are more likely to belong to the first 20 years of the ambrotype period. But murky images, cheaply housed in thin pinchbeck (and not much else), date more probably from the 70s, or sometimes, as the subjects' clothes show, even later. The reason has partly to do with markets. The earlier ambrotypes, though less costly than daguerreotypes, were relatively expensive, and were produced for the reasonably moneyed classes. In later years, when cartes and cabinet prints had brought portraiture into virtually everybody's reach, the ambrotype had some difficulty in competing. But it was sometimes the chosen process of itinerant photographers, and so found itself in competition for a slice of the ferrotype market. Under such circumstances, cheaper production was necessary, and the cheapness showed.

Cartes de Visite

Cartes were introduced to England in 1858. The 1860s saw their heyday, and their immense popularity had waned a little by the end of the decade. They nevertheless continued to be produced in large numbers into the 1890s, and early twentieth century examples can be found. (Indeed, some photographers were producing unmounted carte-sized pictures as late as the beginning of the Great War.)

Cabinet Prints

Though never quite as popular as the 1860s carte, cabinet prints were produced in very large numbers. They were introduced in 1866, but at first

their success was only moderate. They gained some ground in the seventies, became widespread in the eighties, and by the nineties were more common than cartes. They, too, were still being produced in the early years of the twentieth century, though the vast majority belong to the Victorian period.

Tintypes
First produced in 1852 and patented in 1856, tintypes quickly became popular in the United States. In Britain their reception was at first a little subdued, and it was not until 1872, when the Phoenix Plate Company opened premises in London, that they made a major impact. Gem tintypes made their first appearance at the end of the seventies, and the process survived, amongst beach and fairground photographers, even as late as 1950. Effectively, though, British tintypes are most likely to come from the period between the 1870s and the First World War.

Stereoscopic Photographs
Stereos, too, had a long life, with their popularity coming in waves. Pre-Great-Exhibition examples are very rare, and the first main wave covered the period from about 1852 to around 1867. By 1856 they were common, and the International Exhibition of 1862 marked a major peak (or, to preserve the image, a crest). Further surges of popularity came in the 1870s and towards the end of the century, but even during the troughs the stereo was by no means dead.

Postcards
Postcards have not been previously mentioned, because they are predominantly a 20th century phenomenon. The very first British picture postcards appeared at the end of the Victorian age, and it was not until the next reign that the postcard became a standard format for studio portraits. Nevertheless, since there may be a very small chance of a Victorian example turning up in a family collection, brief attention to the postcard is probably appropriate.

The very first British picture postcards appeared in September 1894, and size can be of some help in dating the earliest examples, though it is not foolproof. The still common 5½ x 3½ inch (14 x 9 cm) card dates from

November 1899. Smaller cards, such as 5¼ x 3¼ inches (13.5 x 8.5 cm), or the 4½ x 3½ inch (11.5 x 9 cm) court card, are likely to date from the second half of the 1890s. The change to the new size in 1899 was not immediate, of course, and postcards have frequently been produced in non-standard sizes. For very early postcards, however, dating deductions based on measurements may be made with a fair degree of probability.

Roll Film Prints
Eastman's earliest roll film negatives were circular, with a 2½ inch (6.5 cm) diameter, and appeared in 1888. Round pictures of this size, at least, can thus be pinned down to a period. In the same year a rival company, Stirn, brought out the 'America' camera, which gave 3 x 4 inch (7.5 x 10 cm) pictures. Without the supporting processing service that Eastman offered, however, the Stirn model made much less impact. From 1895 the Pocket Kodak produced pictures that were 2 x 1 inches (5 x 2.5 cm). But it was only with the Brownie cameras of the next century that popular do-it-yourself photography really took off.

Printing processes
Albumen prints were introduced in 1850 and quickly came to dominate the market. They were still being produced well into the 1890s, but demand was then tailing away. Their heyday ran from the late 1850s, with arrival of cartes, until around 1890.

Carbon prints first appeared in 1864 and the process was in fairly common use from around 1870. It was still employed by some photographers until about 1930. The related chromotype had a much shorter lifespan and belonged mainly to the second half of the 1870s. Though a very few practitioners persevered with it into the eighties, the process was rather too complicated for most.

Platinum prints were invented by William Willis in 1873, but did not become a realistic commercial proposition until the formation of the Platinotype Company in 1879. Examples were produced over a period of about 50 years, but their numbers were very low from the First World War onwards, because their vital ingredient became ever more expensive.

Mounts — Physical Properties

Whilst the photographic image of a carte or cabinet print can, of course, be informative, there is much to be gleaned from the card mount to which it is pasted. (It should always be remembered, though, that the date of an image may differ from the date of its mount: photographers sometimes needed to use up old stock, and there was also some copying of early pictures — such as daguerreotypes — for presentation in a more up-to-date format.)

The starting point for examining mounts is the cardboard itself. Broadly speaking, the thicker the card, the later it is. Mounts from the 1860s tend to be thin and flexible, bending as readily as, say, a playing card. But over the decades, stouter and stouter board was used, and mounts from the later years of the century often have a sturdiness that makes them difficult to manoeuvre in and out of album apertures (especially when two such cards are housed back to back). With more substantial mounts came the possibility of bevelled edges, which can often be found from the eighties on. From the last years of the century there are also some examples of scalloped or deckle edges, though this effect belongs mainly to the early 1900s.

There have been attempts to be more precise about thickness, and one American authority, William Darrah, concluded that a mount thicker than 0.508 mm must date from 1869 or later. More will be said later of Darrah's work and the international application of dating criteria. For the present, it is probably reasonable to conclude that measurements in fractions of a millimetre will be of limited help to most family historians. But the general tendency toward thicker mounts as the years advanced provides a useful, if rough, guideline. However, because most of them date from the last 20 years of the century, a selection of cabinet prints is less likely to be easily sorted into thicknesses than is a selection of cartes.

Next there is the colour of the card to consider. In the 60s and 70s pale mounts were usual, but during the 80s and on into the 90s dark-coloured card became widespread. Black, bottle green and maroon were perhaps the favourite colours, and the dramatic effect was added to by white or (for a greater sense of opulence) gold or silver printing. By this time, the thickness of the mounts meant that their edges could be bevelled, so these were often also finished off in silver or gold. Nevertheless, shades of white, off-white and cream never completely disappeared from the scene, though they could be

enlivened by colour trimming. A thin coloured line, often red, violet or brown, often formed a border outside the image and inside the edges of the mount, and such effects are found on mounts from the 60s on. A wider, bolder crimson border around the (possibly bevelled) edges of a cream-coloured mount enjoyed some favour in the 80s.

But the final phase of mount colour, dominant in the early years of the 20th century but already introduced by many photographers in the last years of the 19th, struck a new note of sobriety. The ostentation of deep, rich colours fell out of favour. Varieties of cream and buff were popular, but so were muted shades of grey and dusty green. The finish was often matt, rather than glossy. But it wasn't just a case of reverting to the simplicity of early mounts, for texture became important, both in the card's surface, and in the printing, which was often pressed into the card. The photographer's name (or initials, or signature) was often stamped into the bottom edge of the front of the mount, and this, like the edges, might be picked out in gold or silver. A sense of richness was not abandoned, but it was conveyed with rather greater restraint than had previously been fashionable.

Even the corners of a carte de visite can help towards dating. In the 1860s they were normally square cut, but later they were generally rounded. Caution is necessary, however, since there was a limited re-emergence of squared corners in the 1880s and towards the close of the century. Whilst much the same applies to cabinet prints, the fact that relatively few date from the 1860s means that square corners are more likely to indicate a late example. It is also worth taking a second look at apparently square-cornered cabinet mounts, for they may result from trimming down rather than design. (Album owners seem to have experienced more difficulty with cabinet prints than with cartes, when it came to fitting them into pre-cut apertures.)

One further development that can add to the accumulating evidence is the flyleaf. This is a piece of tissue paper pasted to the top edge of the back of the mount and folded over to the front to protect the image. Plain tissue was common, but printed examples are also to be found. Such slips were too flimsy to last for long, and were particularly likely to be torn off as the cartes or cabinet prints to which they were attached were slid in and out of albums. But a fragment of tissue often still survives where it was pasted to the back,

or, failing that, the telltale stain of the smear of adhesive. Flyleaves were in common, but by no means universal, use in the 1880s and 1890s.

When we turn to stereos, the card itself can once again be a source of help. Very early examples, dating from the 1850s, may be mounted on very thin card, but stouter board came quite quickly into use. Corners were generally square until the end of the 1880s, and often rounded thereafter. The colour of the card may also be relevant, though this is not enormously reliable. There was some taste in the 1850s for mounting stereo pictures on pale grey card, and some use of yellow card in the 1860s. Other colours enjoyed some favour from the 1870s. But colour is not as useful a guide as it is with cartes and cabinet prints.

Stereos printed up as a single piece, rather than presented as two separate images pasted onto a mount, are more likely to date from the 20th century.

Mounts - Design

The overall design of the back of cartes and cabinet prints can also be informative. In the 1860s designs tended to be simple, often just a small trade plate on a large white background. Information was often limited to the name and address of the photographer, though some examples from the early sixties have a completely blank back. Others are occasionally found which have been stamped rather than pre-printed, or which bear a pasted-on label. Eventually it also became common practice to print the photographer's name, and perhaps an abbreviated form of his address, along the bottom edge of the front of the mount, so the absence of such information below the photograph is often an indication of the sixties.

Sometimes, at the end of the 1860s, the back of the mount was designed in landscape format, and this remained an option that was occasionally taken up in the years that followed. A landscape format back could, therefore, come from anywhere in quite a wide span of years, but it is not likely to be earlier than the late sixties.

In the 1870s designs became more ornate and often grew to fill the whole space available. Visual complexity reached its height in the 1880s, when the cards were often packed with information, giving addresses of other branches and listing medals, exhibitions and famous patrons. Lettering could be elaborate. By the late 1880s and on into the 1890s (and coinciding with the

taste for dark-coloured mounts), a self-conscious artistic quality was often found. Information was still copious, but there were often pictures as well: artists' easels, coats of arms, ferns, pheasants, flowers and, especially, cherubs. These are often busy little chaps, sketching earnestly, or taking pictures of ladies who seem in no way discomposed at being confronted by a photographer wearing nothing but a pair of wings.

Also popular in the 1880s, and on into the 1890s, were Japanese motifs. A wave of orientalism swept the country – a wave both capitalised on and further fuelled by its now best-known example, *The Mikado* – and this found expression on the backs of photographs as well as in other contexts. So mounts from this period abound in bamboo, sprays of fruit blossom, parasols, fans and fan-shaped patterns. (This taste is also seen in the Japanese albums that were brought into the UK at the time, where delicately hand-painted pages contrast with heavily-sculpted relief covers.)

When the new sobriety of mount design arrived a little ahead of the new century, it was expressed in simpler, less cluttered backs. Often, in fact, decoration was abandoned completely and backs were left blank.

Mounts - Text

There is always the chance of some handwritten evidence identifying the sitter and giving age or date. Such gifts of information are disappointingly rare, and their rareness should, of course, encourage us to document our own photographs better than we often do, for our ancestors are not alone in failing to provide for the curiosity of later generations. Another possible piece of handwritten evidence is a photographer's reference number. This tied in with the studio's own records and could enable the practitioner to find a negative if a reprint should be required. If a firm or its successor has survived (as very few have), there is just the possibility that its order books have survived as well. There are, too, a handful of studio collections that have passed, with some records, into the care of local archives and museums. But hopes of finding such help, though often expressed, are rarely gratified, and the odds are heavily stacked against such good fortune.

Printed evidence, which may be copious on the back of cartes and cabinet prints, can prove more helpful in the offering of clues. The name and address of the photographer may be significant, and this will be discussed later. But

there may also be dates. Occasionally the card bears a printed date, which, of course, refers to the printing of the batch of mounts rather than the image itself. Unless the photographer did much worse business than expected, however, such a date is not likely to be very much older than the photograph. Dates of a less precise 'not earlier than . . .' variety are more usual. In this category can be found the year in which a firm was established, though the longer this was before the date of the actual photograph, the more impressive and valuable would be its publicity value. Few firms boast of an establishment date until it conveys a sense of respectability and durability. Dates of exhibitions, medals and prizes are also common, and these may be rather closer to the date of the image itself.

Some backs tell of electrically lit studios. Since electric lighting was first used in a photographic studio in 1877, and since there would seem little point in bragging about something that had become commonplace, such mounts would seem, on the face of it, likely to date from the late seventies or early eighties. A few of them, of course, do. But studios were generally quite slow to embrace the new source of illumination, and even in London the initial take-up rate was, for a while, lower than one per year. Some photographers quite genuinely preferred the softer effect of natural light; others were put off by the fact that they would need their own generators. It was, therefore, not until mains electricity was brought to towns during the 1890s that the new form of studio lighting became widespread. This means that the arrival of electricity in a studio might still be something worth drawing attention to in the nineties, and that mounts boasting of it can originate from a rather longer period than one might expect.

Mention of prices on the back of a mount is also less helpful than could be hoped. Prices of cartes de visite, for instance, dropped once they had to compete harder for their share of the market, but it's difficult to draw any guidelines from this trend, since individual studios varied so greatly in their charges. In Aberdeen in the 1860s, for instance, one photographer, George Washington Wilson, was asking twice as much as John Lamb, his competitor. Having a portrait taken by Wilson, who had photographed the Queen, conferred greater social status on the sitter, and therefore he could maintain higher prices. In the face of such variations, attempts to make reliable links between years and prices seem bound to fail.

Also mentioned on the back of some mounts are patented processes that the photographer has acquired the right to use. Many patents were taken out, but two of the more frequently encountered are the Van der Weyde and Autotype processes. The former, invented by the photographer who was subsequently to set up the first electric studio, was introduced in 1872. The latter was mainly concerned with reproducing photographs on the printed page, but is mentioned on the mounts of some photographers from the early 1870s onward.

Turning from process to format, we sometimes find cabinet prints with 'cabinet portrait' printed on the mount. One might expect these to date from a time when such pictures were still something of a novelty and so belong to the sixties or the early seventies. That was certainly sometimes the case. But J E Bliss of Cambridge had 'cabinet portrait' on his mounts, and he didn't set up in business until the late 1870s. It would therefore seem unwise to rely on this detail as a dating aid.

There are two other aspects of text which merit treatment under their own headings, but before they are turned to, a couple of brief points might be made about formats other than cartes and cabinet prints.

In the case of stereos, from the end of the 1850s the publisher's name may appear on the margin surrounding the actual pictures. The lack of a publisher's name does not automatically indicate an early card, but the presence of a name does suggest about 1858 or later. Towards the end of the 1860s publicity information began to appear on the back of some cards, though again, a blank back does not necessarily point to an earlier period.

With postcards, most points that can be made about text relate to the 20th century. But the words 'court post card', as indicated during the discussion of sizes, indicate the period from 1894 to 1899.

Patronage

A clue to dating cartes and cabinet prints might also sometimes be found in the mention of distinguished patrons. 'Photographers to Her Majesty the Queen and Their Royal Highnesses the Prince and Princess of Wales' merely places a picture between 1863 and 1901, but research might lead to something more precise in the case of other patrons.

The most useful clues, however, may be those that are found in references to royal warrants. The photographer who could lay claim to royal patronage had a distinct competitive edge. It was the kind of advantage that, as has been seen, allowed George Washington Wilson to charge nearly twice as much as John Lamb. So it is probably not surprising that some photographers began to depict the royal arms on their mounts and to boast of royal appointments that had never been conferred. An attempt in the 1860s to prevent false claims of patronage brought no significant improvement, and unauthorised displays of arms continued until a private prosecution was brought against the studio chain of A. & G. Taylor in 1884. The company promptly removed the royal arms from its mounts, premises and notepaper, and paid the nominal fine of one shilling with two shillings costs. It was a trivial sum, and the Taylors were rewarded with a genuine warrant two years later, but the point had been made, and control over the use of the queen's name had been regained.

This background information can be put to practical use, if one knows who the genuine warrant holders were during Queen Victoria's reign. Of course, the use of royal arms by the Taylors both before and after they were granted should not be forgotten, but, broadly speaking, two kinds of conclusions become possible. A mount using the royal arms or claiming to be by appointment to the queen is likely to be earlier than 1884, if the claim is false. If, on the other hand, the photographer proves to be a genuine warrant-holder, then (the Taylors excepted) the mount dates from the time after the warrant was granted.

In the case of the Taylors, the phrase 'special royal warrant' was generally used from 1886 onward. In addition, whilst crown, Prince of Wales plume and coat of arms might be used singly or two at a time on earlier mounts, all three motifs often appeared together after the grant of an official warrant.

The guidance towards dating that arises from references to royal patronage may seem limited, but taken in conjunction with evidence of other kinds, it can prove helpful. The necessary list of warrant-holders, with dates, appears among the dating charts near the end of this book.

Names and Addresses of Photographers

The name of the photographic firm and the details of its premises, as found on the back of photographs, can be used in conjunction with trade directories to assist the business of dating.

Photographers, naturally enough, appeared in trade directories. A publisher would bring these out at approximately four-year intervals, but when two publishers served an area, or when there was coverage by both town and county directories, the intervals could often be much shorter. In a series of directories a firm's changes of name, mergers and moves of premises can be traced. The information on the back of a carte or cabinet print can then be compared with the list of directory entries, to see at which point in time the two sets of details are the same.

Two words of caution are necessary. The information in a directory will have been collected over a period of months before publication and may already be incorrect when it appears. A photographer might well use up an existing stock of cards for mounting before going to the expense of having new cards printed. Either directory or picture could thus bear information that had already, if fairly recently, become out-of-date. The conclusion must therefore be that time bands based on photograph/directory comparisons should be treated as approximate at either extreme.

In undertaking such comparisons, the family historian will usually have a fair amount of investigation to do before any kind of conclusion can be reached. But some lists of photographers' directory entries have been compiled. Michael Pritchard's *Directory of London Photographers* covers an area that was home to a high proportion of our ancestors. The Royal Photographic Society Historical Group has published supplements cataloguing early photographers in a number of British towns and counties, and a list of these can be obtained from the group's publications secretary. (Since contact details are liable to change, it is probably wisest to check them out on the society's website at *www.rps.org* .) A further sprinkling of such works has been sponsored by museums, library services and similar organisations, and a few have been privately published.

In the illustration section of this book, Figure 4 provides an example of the kind of dating help that can be given by studio information. It shows, in vignette, the head and shoulders of a woman who is wearing a high-collared

dress of watered silk. The back tells us that the photographer was Shrubsole of Norwich, with premises at Exchange Street Corner and Davey Place. From directories it appears that William Lewis Shrubsole opened his first studio at Ely Place in 1879. By 1888 he had several studios, including the two already mentioned, but in 1890 and 1892 only Exchange Street Corner and Davey Place remained. In 1894 both of these studios had gone, and there was a new studio at Briggs Street. This suggests that the portrait was taken some time after 1888 and before 1894, with 1890-1892 as the known time when just the right combination of studios existed.

With most photographers' addresses the researcher will hope for a published short cut to dating, whilst recognising that a laborious trawl through trade directories may prove to be necessary. It is possible though to offer a little very general help in a few special cases. A number of photographic multiples grew up during the Victorian period, and their tendency to list branches on their mounts can be helpful. It would be unwise to assume that a given mount lists all currently active premises, but mention of a studio at least means the mount is not earlier than its establishment. Since the spread of a chain increases the likelihood of an example of its work turning up in a family collection, a brief account of some major operations is given here. Much fuller information can be found in the articles by Audrey Linkman and Colin Osman that are listed in the bibliography.

Biggest of all the multiples was A. & G. Taylor, whose royal adventures have already been mentioned. Based in London, the company grew from a business originally established in Cannon Street in the mid 1860s by Andrew and George Taylor. The beginnings of expansion came in the mid-seventies: Liverpool, Manchester, Glasgow and Leeds had been added to the chain by 1877, Birmingham by 1878, and Bristol, Newcastle and Nottingham by 1879. In 1880 there were some 25 UK outlets, and by 1890 this number had grown to around 50. Premises were opened in Paris and in various American cities in 1879, but both forays abroad were fairly brief, and the American venture was disbanded in 1880. The business continued into the 20th century.

Rather smaller, but still catering for a mass market on an impressive scale, was the Liverpool-based firm of Brown, Barnes and Bell. Founded in 1876 or 1877, the company opened its first London studio by 1880. It flourished during

the first half of the eighties, running up to a dozen additional studios in Scotland, northern England and the Midlands at any one time. The operation passed into new ownership at the end of the decade, though the name was retained, and there followed something of a decline. The once-busy central printing works at Liverpool's Mount Pleasant seems to have been given up around 1887. But though the empire contracted, studios in both Liverpool and London survived into the 1900s.

An earlier chain was that of the London School of Photography, owned by Samuel Prout Newcombe. Set up in the 1850s, the School had a series of London addresses and also ventured into Manchester and Liverpool by the end of the decade. But these operations beyond the capital do not seem to have continued long in business. Two of the London studios lasted into the eighties, and one of these made its last appearance in a trade directory for 1891.

A distinctive marketing policy characterised Hills and Saunders, who concentrated on the sector of society that followed a public school education with a military commission or a university degree. The partnership began with an Oxford studio in 1860, and subsequently saw the establishment of studios in Eton by 1864, and in London, Cambridge and Harrow by 1869. Aldershot and York Town were added by the early eighties, and possibly earlier. The partners went their separate ways at the end of the eighties, but the company name lasted well into the 20th century.

There were also more localised chains, of which London's Hellis & Sons is quite frequently encountered. Over the years it occupied permutations of nearly 20 different premises, but much of its work was done in the Edwardian years, and Victorian examples date from the period's last decade. (The chain grew from a studio at Notting Hill that had been run since the seventies under the name of R. Hellis, but expansion under the family name seems not to have begun until about 1890.)

It will have been noticed that no mention has yet been made of the family historian's tried and moderately trusted friend, the census. Certainly photographers named on photographs may be linked with their census addresses, but censuses are a full ten years apart and are likely to name the practitioner rather than the firm, and to give a home address which may or may not have been used for business. On its own, therefore, the census is

likely to be of very limited use, whereas a directory gives a commercial identification in a form just like that used on the mounts themselves. At best, a census may provide supporting evidence when taken in conjunction with information given by trade directories.

Dating the Image

Studio Background and Props

The studio settings in which subjects were placed can be a source of much pleasure and entertainment. Young ladies sit, in their indoor best, in leafy glades and before turbulent seas. Children stare insecurely out from seats of swings set at a frozen tilt. Babies sag in voluminous furs, half propped up by parental hands sticking out from between the folds. Clerical gentlemen try to look erudite in studies full of painted-on book spines. A young man grips the back of a chair conveniently found by a lakeside. A family poses against a background of outdoor classical architecture that is half hidden by an incongruous indoor curtain.

As well as affording innocent amusement, the backcloths, furniture and props of the Victorian photographer's studio can offer hints as to the date of a picture. Of course, settings do not provide infallible guidance, since, especially in the provinces, a photographer might hang on to his props and furnishings for years, shuffling them about in new combinations. Nevertheless there were fashions, so the studio trappings, when considered in conjunction with other kinds of information, can suggest time bands which can be compared to those indicated by other evidence.

In the 1860s (and in the late 1850s as far as cartes are concerned) settings were generally relatively simple. Some subjects stand or sit against neutral backgrounds, with or without a curtain hanging down at one side. If the subject is seated, he or she may be at a small table or writing desk, and may be holding a book. The taste for drapery, seen in curtains, may extend to a table covering as well. Also favoured in the middle of the decade was the classical look. Columns, arches, plinths and balustrades abound, often supplemented by the ubiquitous length of curtain. As the sixties drew to a close, chairs remained a popular prop, but were often present for leaning on with one hand, rather than for sitting purposes. Also at the end of the decade came a taste for painted windows or archways looking out on a painted country scene. This fashion faded away in the 1870s when, instead of offering

mere glimpses of a supposed rural world, the photographer's studio often simulated a move out into the open air.

Though indoor scenes continued to be used (and, indeed, never fell out of favour), the 1870s were the years when the rustic background came into its own. Large backdrops of natural settings were used, and props were provided to match. We see stiles, rock gardens, bridges, fences and landscaped steps set against masses of painted foliage. Any studio might offer the background of a woodland pool; the more ambitious might add a cardboard swan. Seaside backgrounds also started to appear.

But nature in the 1870s studio tends to be kept under human control. Fences and stiles are often of cleanly planed wood, and if a straight-from-the-tree look is attempted, the palings may at least have had their bark removed. Some real plants might be introduced, but most were confined to the backcloth.

The chair was still popular, and could be introduced into improbable outdoor contexts as well as furnishing drawing room settings. By the latter part of the seventies, chairs were increasingly elaborate with padded backs, in line with their common function of being leaned against instead of sat on. Padded rests and lecterns served the same purpose and, like the chairs, continued into the new decade.

Occasionally in the eighties a wholly new setting, such as a railway carriage, may be found. But what the decade frequently offers is not something essentially different, but rather the proven recipe made up to a richer mixture.

Texture becomes more important. The timber used for gates and fences is likely to be covered in bark. Artificial boulders and tussocks strew the ground. The balustrade – often more weathered or mossy than before – makes a comeback. Seaside settings become more rock strewn. Backcloths often tend towards the rugged end of romanticism. There may even be some attempt to suggest natural materials underfoot, though the Victorians never became too concerned about realism at the point where scene-painter's artwork met studio floor.

There is often some attempt to cater for children with ships' masts and rigging for boys, and perhaps swings, suspended from conveniently unseen branches, for girls and young ladies. And indoors (for indoor settings had not

become extinct) an oriental flavour may be added by a Chinese or Japanese screen.

In the 1890s the taste for a touch of the exotic, already shown by oriental screens, might find expression in hothouse pot-plants, palm trees and even cockatoos. The desire for a sense of modernity might be satisfied by the inclusion of a bicycle. Babies snuggle in rugs of white fur and adults pose by mirrors. There can be a highly contrived air about garden sets, with art triumphing firmly over nature. One way and another, there can be a sense that the designer-photographer is trying hard.

There was also a modest revival of backcloths depicting indoor scenes. Such latter-day interiors often show rich panelling, with trompe l'oeil suggestions of corners and alcoves. When windows are included in the scene, attention is often paid to the light coming through them and striking the sill or side panels (though the direction of painted light does not always accord happily with the direction of light in the studio). Such chiaroscuro effects were not generally attempted when windows were painted on the backdrops of the 1860s.

Yet studio contrivance is not the most obvious feature of pictures from the nineties, since a significant fashion in composition was for a close-up of the sitter, with little or no background in evidence. Studio settings, when seen, might be wilfully fanciful or painstakingly realistic, but concentration on the face, as described in the next section, was much more characteristic of the decade.

Composition and Framing

Even the way in which the photographer dealt with the subject can reflect the changing fashions. Whilst it may be considered only a rough guide, the closer the camera is to the sitter, the later the photograph was taken.

In the late 1850s and in the 1860s the full-length figure is most common. The figure may be standing or sitting, perhaps with a book in hand, but in either case the feet are likely to be included in the picture. But the feet of single seated figures, in particular, are not usually seen in pictures from the 1870s and later. (The use of a chair or chairs to give tightness and variety of height to a small group was, and remains, a natural strategy, and the camera has to draw back to fit everybody in. So pictures of two or more people are

less datable in this way.) As the 1860s progressed, the full-length standing figure using a chair or balustrade as a hand rest became a popular image.

Exposure times depended on the quality of light, and several seconds of immobility could still be needed throughout the 1860s. It was standard practice, therefore, to steady the subject by using a headrest or neck-clamp. The bases of such devices were easily hidden by women's skirts, but they can often be seen behind the feet of men and boys. Sometimes a drape has been pulled across at an angle to hide the base. Whilst steadying devices were still sometimes used in the 1870s, signs of their presence are less likely to be noticed. This is partly because shorter exposures meant a declining need, but partly, too, because the evidence was less likely to fall within the frame of the picture.

In the 1870s and 1880s the camera tends to move closer. Figures are presented in three-quarter length, with the bottom of the picture cutting across a line somewhere between shins and mid-thigh. A chair (by now, often, just the visible top part of a chair) or a lectern-like rest is still there to hold on to, especially in the 1870s. Seated figures are less common, and, when they occur, their feet are likely to be out of the picture.

As the 1880s moved into the 1890s, the camera came in further still, and the last decade of the century was very much the age of head and shoulders portraits. This closing-in was frequently further emphasised by the practice of vignetting, whereby the outer parts of the picture are white, and the head and shoulders appear in an oval exposed area in the centre. The oval (or roundish) shape is sometimes very distinct. Sometimes, because the background is pale anyway, the fading away of the image into whiteness is most evident around the shoulder line, with the head standing out strongly against the all-white background of the upper part of the picture. Techniques for vignetting were not new. They had been in use for decades, and one method had been patented by John Mayall in 1853. But for many years they remained simply an option that a practitioner might employ from time to time. At the end of the century, however, the vignette became so commonplace that it dominates the 1890s pages of family albums. Its huge popularity can be a little depressing to the modern eye, because it cuts out details of clothing and studio setting. Nevertheless, the technique is highly characteristic of the decade, and vignettes were produced in such quantities

as to overwhelmingly outnumber the combined examples of earlier years. As a result, the odds are very high that any one vignette belongs to the nineties.

There is, though, one possible area of confusion, and that is the practice of framing the image as a medallion. Some very early English cartes, produced by the firm of Marion and dating from the late 1850s, comprised an oval portrait measuring about 2 x 1½ inches (5.1 x 3.8 cm) pasted to an absolutely blank mount. As early as the 1860s photographers were creating cartes de visite on which two or more portraits were presented as head-and-shoulders images in oval or circular panels displayed against a plain background. Such images took much the same shape as the vignettes which dominated the 1890s, and the portraits inside their framing medallions were themselves sometimes vignetted. In fact, versions of the medallion format were produced over many years: the earliest kinds appeared at the beginning of cartes' history, and they continued to enjoy some popularity throughout the Victorian photographic period. Some specific variations of these pictures are, however, a little more datable.

The diamond cameo portrait carte bears, arranged in a diamond shape, four small oval pictures of the same subject. It was introduced in 1864. Early examples may carry a motif naming the format and incorporating the initials 'W & B'. But whilst some photographers acknowledged the diamond-format originators – Window and Bridge – in this way, others very quickly made the layout their own, with no reference on the mount to its name or pedigree.

The bi-medallion, or doublet, featured two oval portraits side-by-side and contiguous. Sometimes the same subject was shown from two different angles, but the format also proved popular with couples. Because the two ovals are fitted into the space in portrait rather than landscape format, they are noticeably long and thin. This style of carte does not seem to have made an appearance before 1870.

The cameo medallion, or cameo vignette, has a relief effect, for the central oval (set against a darker background) has been pressed to give a raised, curved surface, rather like that of a cameo brooch. This style of presentation did not arrive in Britain until 1871. Examples of raised rectangles with rounded corners are also sometimes encountered, and these first appeared at

the end of the seventies. Both shapes continued to find some favour until the end of the century.

Outdoor Photographs

In outdoor pictures there is, at least in theory, some chance of dating the scene from its details. Unfortunately, however, though there were professionals taking outdoor pictures before the advent of roll film, the vast majority of family photographs set in the open air are from roll-film cameras, and from those popular models which date from early Edwardian rather than late Victorian times.

There are certainly datable objects that could appear in 19th century outdoor photographs. When Queen Victoria died, trains were long established, telephones (and, hence, telegraph poles) had arrived, and street lighting was already starting on the transition from gas to electricity. Pneumatic-tyred bicycles, with a fairly modern look, had been around since the 1880s; electric trams had started to appear on the streets in the 1890s; and in the last years of the century the motor car had made its début, with the Prince of Wales taking his first ride in 1898. Even manned flight had made a modest beginning, with Sir Hiram Maxim's flying machine travelling through the air for a distance of some three hundred feet in 1894. Nevertheless, it was not generally family photographers who were recording these new and datable inventions.

But major happenings have a particular appeal to photographers. Queen Victoria's Diamond Jubilee, for instance, coincided with the early years of roll film (if not with the massive boom in its use just after her death) and produced a land full of decorations, processions and celebrations just asking to be recorded. There is, therefore, just a chance of a special event picture surviving in a family collection, and if the locality is known, it should be possible to obtain useful advice on the nature and date of the event from archivists, libraries, local history societies or newspaper records.

Costume

Clothing is a very good pointer to a photograph's approximate date. The more conversant one is with the history of costume, the more clues one can find in

a picture. The topic is a large one, and one where the average investigator of family photographs may be inclined to stop short of thoroughgoing expertise. But even the untutored eye can accustom itself to picking out some useful information, and it is to the moderately willing, if untrained, eye that this section attempts to offer assistance.

As ever, there are warning notes to be sounded. People tended to wear their Sunday best to the photographer's studio, and that best may have been required to last for a good few years. So clothes may not be entirely up-to-the-minute. Generally, the older the sitter, the more likely he or she is to be out of fashion. There could be a time lag between London and the provinces, so sitters outside the capital – as well as sitters who were less well off – might not take up new fashions for a year or few. Fashion details tend, therefore, to give an earliest rather than a latest possible date.

Men's clothes in particular can be difficult to date. Some of the changes they underwent were less dramatic than those of women's clothes, and men, especially once they reached middle age, were less likely to keep up with fashion. Perhaps more to the point, though, is that details can be harder to distinguish on men's often uniformly dark clothing. One field of male costume that may be uncharacteristically datable is military uniform. This, however, is rather a specialist field, where the regiment has to be identified before progress can be made, and where background research may need to be extensive and supported by informed advice.

If all this seems discouraging, it should be re-emphasised that details of costume can, in spite of problems, give the lay viewer very significant aid. Whilst the majority of surviving photographs date from the 1860s and later, some attention is given here to clothes of the preceding years as well, since a few family historians are lucky enough to have earlier pictures in their collection.

Women
By starting with a consideration of line and impression, we fall immediately into generalisation. Nevertheless, some idea of the broad trends gives a useful starting point before particular aspects of clothing are dwelt on.

In the 1840s women wore fairly close-fitting garments on the top half of their bodies, whilst skirts were fairly full, giving a smooth bell-shape. In the

fifties and sixties the contrast between the close-fitting bodice and the full skirt became far more marked, for this was the age of the crinoline. The 1870s saw the first period of the bustle, which sloped away into a full, uncrinolined skirt. This was generally a decade of complicated designs, and a very popular look in the early 1870s was the 'Dolly Varden' dress, where the bodice was connected to a short, bunched-up overskirt, with a full, loose skirt below. In the first half of the eighties the Princess line came into vogue, with its tight, long waist brought to a point in front. The eighties also marked the second period of the bustle, though this time it was worn high, jutting out from the small of the back. In the latter half of the eighties the tailored suit with blouse made its appearance, and this went on to prove even more popular in the nineties. Corsetry was often tight through both eighties and nineties. By the nineties, however, the fashion emphasis had switched. If the earlier decades had stressed the skirt, with crinoline or bustle, the nineties paid more attention to the top half of the body, with a highlighting of arms and shoulders. Skirts became relatively plain.

All of this is very general, but when particular garments are considered, some more detail can be added to the picture.

In the earliest photographs, clothes appear to fit the upper body and arms fairly closely, and in the period of the crinoline, from about 1850 to about 1865, the bodice was noticeably cut to hug the figure. As the fifties gave way to the sixties, there was a fashion for epaulettes on the shoulders, marked with braid trimming, and these continued to enjoy some favour until the early 1870s. Sleeves in the 1860s were generally wide, long and set in low on the shoulder. The upper part was sometimes puffed, and the general effect, especially in the first half of the decade, was of a markedly sloping look to the shoulder line. In the late sixties and early seventies a square-yoked effect to the bodice was popular, and this might be defined by braid or fringing. A fashion that followed in the mid-seventies was the cuirasse bodice, with a front panel and a military air. During the seventies the overall shape of the bodice remained simple, and sleeves were set in high on the shoulder, so that the sloping look disappeared from about 1870. In the 1880s bodices tended to be closely figure-fitting and buttoned up to the throat, whilst the nineties saw a variety of blouses, jackets, short boleros and dress bodices cut to look like jackets. All were popular, and all could be distinctly elaborate. At the

very end of the eighties things started to happen to sleeves. At first there was the narrow sleeve, brought to a peak at the shoulder. The peak grew fuller and more rounded until, in the mid-nineties, it had taken on the puffed-out appearance of shoulder or upper arm that is well-known as the leg-of-mutton style. There was also some vogue in the middle years of the nineties for a rather different kind of sleeve which was three-quarter length and which ended in a frill. Towards the end of the century the leg-of-mutton look disappeared rather abruptly, and sleeves became close-fitting all the way down. At the turn of the century their tightness might be relieved by a little fullness or puffing at the shoulder, but they no longer ballooned out, and they were often long, sometimes covering half the hand. Blouses and bolero jackets, often highly elaborate, were also both favoured in the nineties, though they became, if anything, even more popular in the early twentieth century.

Below the waist, too, fashion came and went. The smooth, bell-shaped skirt of the 1840s became increasingly full. For the first half of the 1850s it was filled out by multiple layers of petticoat, but 1856 saw the introduction of the cage crinoline, a hooped petticoat held out by whalebone or watch-spring. By 1860 the cage crinoline was at its widest, sitting was a major undertaking, and two women could not occupy the same sofa. In the second half of the sixties the fullness of skirts began to recede; many women abandoned crinolines altogether, and the half crinoline (the back half) made a brief appearance at the very end of the decade. Once the crinoline had disappeared, the general tendency was for skirts to be flatter at the front but full at the back. This fullness turned, in the late sixties and first half of the seventies, into the bustle, where the folds of flowing material were caught up into a bunch behind. This bundle of swathed material fell away in a sloping line at the back of the skirt. One lady, asked how she achieved such an effective bustle, confided that she padded it out with newspaper, and that she found *The Times* particularly suited to the purpose. Frills, ribbons, buttons and fringing were all called upon, in the first half of the seventies, to aid the general splendour of the effect. Skirts remained flat-fronted through these years and into the eighties, but in the latter half of the seventies the bunched-up bustle lapsed from favour, though the garments remained full at the back, often falling into a train. In the first half of the eighties the bustle made a

return, though with a changed silhouette: instead of sloping away it was higher and larger, sticking out horizontally from the small of the back before falling away sharply towards the ground. The overskirt disappeared by about 1894, and the nineties (and the first decade of the twentieth century) saw simpler skirts, tight at the waist, smooth over the hips, and flaring out, bell-shaped, below.

Whilst skirts and bodices account for the main features of a particular look, there remain other details to consider. The head and neck were also subject to the dictates of fashion. At the end of the 1840s hair worn in dangling side ringlets, with a bun at the back, was common. In fashion too, though also found both earlier and later, was the bonnet with a full, forward-pointing brim, and with ties under the chin. In the fifties relatively plain hairstyles were favoured, with the hair smoothed back into a simple bun from a central parting. For day dresses, necklines were high, with a small collar and, perhaps, a brooch. The once-universal, small, white indoor caps had, by about 1855, been largely discarded by the younger women, especially those who were unmarried, in favour of ribbons or hairnets. Simplicity of hairstyles was often preserved into the 1860s, though the visibility of ears can provide additional information. Hair tended to cover the ears in the earlier part of the decade, whereas ears were more likely to be exposed from the middle to late sixties. Not all styles of the sixties were simple, though, for the chignon style became common, with the hair massed over a pad at the back of the head. In the second half of the sixties a pork-pie style of hat had some currency, worn square on the head. Hats that were tilted forward marked the transition to the next decade and accommodated increasingly massy hairstyles. The 1870s were very much the age of the elaborate coiffure, particularly in the earlier years, with ornate styles built up on artificial hair, and with the back of the head echoing the shape of the back of the skirt. One firm at the time was said to be turning out two tons of artificial hair a week. In the second half of the decade the exuberance died down somewhat, and the bun made a reappearance, now often worn high on the head. In the seventies, too, Princess Alexandra adopted the fringe, which she was to wear for the rest of her life, and she was much copied. Necklines of the seventies were varied, with use frequently made of scarves and jabots. In the eighties hair and necklines calmed down. Small standing collars became popular,

buttoned to the throat and perhaps set off with a piecrust frill. Hair tended to be more simply dressed, following the outline of the head in smooth contours, with the bun, if worn, at the back rather than on top. The fringe survived on many heads, frequently (especially in the early eighties) with a crimped, straggly or tousled look. But if hair and collars took on a degree of sobriety, all of the imagination went into the hats, which could be trimmed not just with fur and feathers but with the original owners of the fur and feathers. Whole dead creatures, birds, their nests, small rodents and even large insects were all called on to decorate outdoor headgear. The indoor white caps were, by the later eighties, worn only by old women; the younger married women had followed the unmarried in dispensing with their use. Elaborate hats reminiscent of a natural history museum survived into the nineties, though any one hat might carry a smaller and more modest range of wildlife decoration than in earlier years. Smaller hats, firmly centred on the head, were often worn, though they still often sported at least a feather or two. The straw hat or boater also enjoyed the favour of women as well as men. Necklines became very high for day dresses, with stand-up collars, and with the piecrust frill still much in evidence. The bun was still widespread in the nineties, but fringes had become rare, and the last few years of the century saw the 'door-knocker' or 'teapot-handle' style, with hair looped or coiled at the back of the head.

Finally a word might be said about general trimmings, pattern and colour. The 1860s, especially the first half, were often marked by a taste for geometrical patterns on skirts and sleeves. Dresses in the 1870s were often loaded down with trimmings. Significant improvements had been made in sewing machines in the late fifties and in the sixties, and these bore fruit in the fancy stitching, frills, ornamental buttons and fringing of women's clothes. New dyes led to brighter colours, though these are only hinted at in monochrome photographs. A mixture of colours and materials in the same dress was common, sometimes creating an effect suggestive of patchwork. The eighties saw an inclination towards plainer clothes and more severe effects, though the contrasting tendency in headgear has already been noticed. The nineties, were marked by a growing taste for the use of lace, especially on blouses, and by the craze for jet ornaments.

It is, perhaps, a pity that so much invention and industry should now present itself to our eyes in muted black (or sepia) and white.

Men

To move to the consideration of men's fashions is to enter a simpler and rather more sober world, which was subject to less frequent changes. This was not necessarily because the male did not take trouble with his appearance, but rather, perhaps, because he was busy projecting a different kind of self-image on the world.

As with women, the overall look provides the starting point. In the forties and on into the fifties suits were tight and fitted close to the body. Towards the end of the fifties they became looser fitting, with wider sleeves and legs. It was not considered necessary for the top and bottom halves of the ensemble to match, and until the mid-sixties a dark jacket worn with light trousers was common. By the second half of the sixties the lounge suit had achieved a degree of popularity and was often characterised by deep cuffs. In the seventies suits became tighter again, even though the jackets were often double-breasted. A rather straight, narrow line to male costume persisted through much of the eighties until, at the end of the decade, a baggier look to suits came in and lasted to the end of the century. Lounge suits, introduced a good while earlier, were very widespread indeed in the 1890s, and from about 1900 they were to become normal day wear.

Some of what can be said about jackets has been said in the course of considering the ensemble, but a few more details of upper-body garments may be added. In the 1840s waistcoats often bore fancy patterns, and not until the mid-seventies was it customary that they should match the jacket. From the late fifties jackets were generally fastened by just the top button. Particular styles appeared, or had their moment of glory, at particular times. The short, double-breasted 'reefer' jacket found some favour in the 1860s, especially amongst men of the lower-middle and labouring classes. Interestingly (and encouraged perhaps by some taste for shorter jackets amongst young men in the late seventies) the reefer jacket was often chosen in the first half of the eighties, and a little beyond, to convey a sporting look. This may be a fairly unusual example of a fashion becoming upwardly mobile. Norfolk jackets, with a belt and vertical pleats, came in during the

second half of the 1870s and grew considerably in popularity in the eighties and after. From about 1894 the Norfolk jacket often had a yoke set into it – a feature not normally found earlier. The blazer, worn as a sports jacket, dates from the late seventies, and 1888 saw the arrival of the dinner jacket (known, though, as the dress lounge jacket until 1896). The jackets of lounge suits in the 1880s often had very short lapels, below which they were fastened on a single button. Some men persevered with this style as they grew older, so the high-buttoned look is also often seen in pictures dating from the 1890s. One final piece of torso-wear, the cummerbund, became popular with formal dress in the 1890s.

Some details of trousers can also help with dating. In the fifties and early sixties peg-top trousers were in vogue. Wide-legged, but tapering to a close fit at the ankles, these garments were often striped or checked. In the late fifties and through the sixties a raised or braided side seam was fashionable, and such emphasis on seams became a standard feature of evening dress trousers from the 1870s. Knickerbockers, loosely cut and gathered into a band below the knee, made their first appearance in the 1860s but are of little real use for dating, since they enjoyed a long life on into the twentieth century. The first half of the nineties saw a brief comeback for the peg-top trouser, though for this incarnation it was more usually made up in plain material. During the same half-decade, turn-ups featured in the wardrobe of the more dashing young men, though they were not to become a standard feature of trousers for some years yet. In the mid-nineties the trouser-press was introduced, and creases were subsequently often in evidence.

Turning to the extremities, feet in the forties and fifties were often encased in square-toed shoes. In the seventies and eighties, toes were relatively pointed. Spats can be found from the 1870s onward.

Further up the body, high coat and shirt collars mark the early years of photographed history, with the large, loose cravat being favoured through the forties and fifties. Ties of a rather narrower kind gained ground from the mid-sixties. The end of the century saw high shirt collars return with a vengeance, with a maximum height of some three inches being reached by 1899. The high collar continued into the new century.

Last comes the hat. The top hat was worn throughout Victorian times, though by the end of the century it had taken on the formality with which it

has ever since been associated. There were, however, some changes in design. In the forties and fifties the crown tended to be very high, and pictures of men in stove-pipe hats generally date from this early photographic period. If the medium-height crown is then taken as the norm, two periods of relatively low crowns can be discerned — the 1860s and the 1890s. These lower crowns were quite common in these decades, but they were by no means universal. Top hat brims also underwent change. Before about 1865 the brim was flattish. There may have been some curling of the sides, but the line where brim joined crown was straight. From the mid-sixties a noticeably curved line of brim was often apparent. In the seventies, especially in the second half, top hat brims were often, though not always, rather narrow. The bowler of the sixties often appeared low-crowned, narrow-brimmed and rather flat-topped, with an outline something like that of a pudding basin. In the seventies a rather high-crowned bowler was common. In the eighties and nineties the bowlers were medium-crowned with curled brims, and they had a generally modern look. The homburg first became popular in the mid-1870s and the straw boater came in at much the same time, though not until the nineties did it enjoy its golden age.

Children

A systematic account of children's clothing would give limited aid in dating, often indicating the age of the child rather than the age of the photograph. (The older the child, the longer the skirt or trousers.) Sometimes children's clothes echoed those of adults. Girls, like women, wore crinolines for instance, though theirs were shorter, revealing ankle-length pantaloons, and their bodices were often low-necked and short-sleeved, proving more like the evening-wear than the day-wear of their elders. There were, however, some aspects of children's fashions that can help towards dating, even though the long life of certain styles means that this help may be rather vague.

Full-length trousers on young boys are generally a pointer to the forties or very early fifties. After that, trouser length related to age. For both sexes a Scottish flavour was popular during the sixties and seventies and expressed itself in plaids, sporrans and tartan dresses. The taste for dressing sisters alike, except for the age-related skirt length, was perhaps strongest in the sixties and seventies, though it is a taste that seems never wholly to have died

out. About half way through the sixties sailor suits for boys began to put in an appearance, and this nautical look became increasingly popular through the seventies. Girls' versions appeared by the eighties, with a skirt complementing the sailor top, and the fashion survived through the rest of the century and beyond. The seventies produced dresses for girls as elaborate as those of their elders. In the eighties smocked yokes came in as something of a novelty, which went on in later years to become almost de rigueur. The eighties, too, produced a new fashion in boys' clothing, influenced by the eponymous hero of Frances Hodgson Burnett's *Little Lord Fauntleroy*. When the book was published in Britain in 1886, parents (though not necessarily sons) went overboard for the Fauntleroy look, with its velvet trousers and jacket, its broad frilled collar and its ringlets. The individual ingredients of the style were not necessarily unusual, but their combined effect was new and distinctive. Late in the eighties, lace-up shoes for children became an alternative to the previously standard buttoned boots. In the nineties a sombreness of colour crept into clothes for both sexes, with styles firmly echoing those of adults.

Babies are particularly difficult to date, and if they can be placed at all, it is often only because of the context in which they are presented, held by a mother wearing clothes of the seventies, or cushioned by the white fur of the nineties. It is to the early years of the 20th century that the tradition of naked baby on rug belongs. But the 1890s did see a foreshadowing of that Edwardian convention with the appearance, on occasion, of bare feet and legs and off-the shoulder shifts for babies and very small children.

Before leaving children's clothes, one point should be made which has to do with identifying the subject rather than dating the picture. With children of pre-school age, skirts and long hair are no guide to sex, for small boys and girls were both dressed in the same way through Victorian and Edwardian times. The sweet little girl on Great-Grandmother's lap may very well be Grandfather.

The Dating Process

Combining evidence

Dating photographs is rarely an exact science, and it is often possible to allocate a photograph to nothing more precise than a decade. Nevertheless, greater accuracy can sometimes be achieved, and this frequently results from the accumulation of evidence of different kinds. It can, therefore, be worth taking the time to compare all the dating clues gleaned from an old photograph. The more they agree with each other and point in the same direction, the more confidently one can draw conclusions about a probable date or, more usually, date range.

Sometimes specific details can be taken in conjunction to narrow the possible time span. It may be, for instance, that a particular studio address is known to have been used over a 15 year span, but that a particular fashion of dress did not emerge until half or two-thirds of the way through that period.

But sometimes clues seem to give conflicting evidence, and that, too, is of interest. Where there are apparent contradictions, first rule out the impossible. (However much a backcloth may appear to date from the sixties, for instance, the picture must be later if the subject is wearing leg-of-mutton sleeves.) Then consider how the remaining possibilities can be reconciled. The conclusion may well be that a picture dates from a period of transition: a practitioner may be equipping the studio with the latest furnishings while the subject is dressing conservatively and resisting the newest fashions; or the studio may still have a look of the 1860s while the photographer has invested in classy new mounts with an all-over design. A photograph that gives out different messages may seem to confuse, but certain sorts of confusion may actually belong to fairly definable periods of time.

Studying an Album

The photographs of an inherited album should be returned after inspection to their original positions. The owner will naturally wish to slip them out, study the backs and check the margins for any handwritten note obscured when the picture sits in the album. To avoid wear and tear on the picture

surrounds, the researcher would be wise to make a note of information from the back before replacing the picture. It may be helpful to use a numbered sheet of notes for each page of the album, dividing the sheet according to the number and position of photographs on the page, and writing the notes in the space corresponding to the photograph. In this way writing on original pictures and album pages is avoided, and the removal of cartes and cabinet prints is kept to a minimum. To notes dealing with information on the reverse may be added any identification and dating that can be suggested, along with cross-reference to other examples thought to be showing the same sitter.

Returning photographs to their original positions is important, because those positions may be significant in identifying the subjects. A husband and wife may face each other; children may have been arranged in order of age; generation order may have been preserved, with the earliest pictures quite possibly pre-dating the album itself.

Amongst the pleasures of looking through an album may be tracing family resemblances and finding images of the same person at different ages. Here dating may be used to encourage or question emerging opinions about perceived likenesses. It should be borne in mind, however, that it is easy to jump to false conclusions. The photographs may have been rearranged many times and may not all be of family: friends, neighbours, in-laws and local or national celebrities may all be included, too.

There is a good chance that an album will contain a number of pictures taken at the same studio over a period of years, and attempts to date pictures by the names and addresses of photographers can become more fruitful when there is more than one example to work on. Where no directory of old studios exists, the laborious task of sifting through a series of trade directories can seem more worthwhile if a whole series of photos is under investigation.

A studio collection can also have its own story to tell, quite apart from what may be found in directories. It can, for example, give an extra dimension to the business of dating by mount design. A series of photographs sorted into apparent mount order can prompt thoughts about how their images are related in time, sharpening the focus on the ageing of an individual or helping to distinguish between generations. Sometimes, too, matching mount designs and similar poses will suggest that two separate pictures are actually a pair taken on the same occasion. (It was not unusual for couples to be

photographed separately and posed so that they would face each other across the album page, but such an arrangement of images has not always survived later reshufflings.)

Whilst the obvious way of putting a studio sequence into chronological order is to sort it by mount design, there are other possibilities. The most unequivocal is the presence of hand-written negative reference numbers on the backs. Numerical order is date order, and pictures taken on the same occasion are impossible to miss. There is one possible source of confusion, if a photographer has moved to a new address or entered into a new partnership, and has used that occasion to launch a new record system. But such a fresh start should not be too difficult to recognise. The often-changing pattern of studio proprietorship can also throw up its own kind of illumination. Overprinting a new owner's name on the departing photographer's unused mount stock was a common practice. So was the mention, with an eye to the goodwill, of the previous operator's name on the mounts of a new arrival. Both can help the researcher to clarify the sequence of a group of pictures. Even unbroken occupation of a studio can be the cause of helpful information. A mount for London's Parisian School of Photography which announces that it has been 'Established over 25 years' proves much more enlightening when on another of its mounts are found the words 'Established 1851'.

Finally, the locations of a family's chosen studios can be related to known movements, can help with the separation of one branch from another, and can suggest new possibilities for census searches. If a meaningful pattern is suspected but not immediately seen, it may be worth mapping an album. Mark the studio towns (or even streets) on a map, and add to each location the total number of photographs originating from it, and a note of the apparent time span covered by its pictures. The resulting diagram will fall well short of proving anything, but it may suggest possibilities worth investigating.

Pictures from Overseas

Photographs from abroad are often found in family albums, sent by emigrant branches or those serving the Empire. For them, the exchanging of pictures gave substance to their efforts to maintain contact. This book has no pretensions to be an authoritative guide to dating such images, but it does

seem reasonable to wonder how much they have in common with the home-grown product.

Certainly, commercial photography developed in different ways in different places. Conventions and practices of colonial studios are perhaps closest to those of their British counterparts. But Europe and, increasingly, the United States had their own traditions and ways of life that we might expect to see reflected in their photographs. People may look a little different from place to place, with an element of local idiom apparent in hairstyles and dress (such as the close-cropped hair of small American boys or the visible shirt tails of their French counterparts). Mounts, too, may vary, showing design details that have national roots, while vignettes with a dark rather than a pale background seem to have been more popular in France than elsewhere.

What is surprising, though, is how much pictures from different places seem to have in common.

There was, from its earliest days, a high degree of internationalism in photography. French introductions, the daguerreotype and the carte de visite, very quickly spread across the globe. Within months of Daguerre announcing his breakthrough, instructions for his process were circulating in a dozen languages, and even in England — one of the few countries where practice was restricted by patent — enthusiastic emulation was only delayed for a couple of years. Cartes took a little while to catch the imagination, and needed the boost of eminent patronage both in France and Britain, but, once established, they were a global success. The triumphs of Disderi in France and Mayall in Britain were quickly emulated by Lewitsky in Russia, Angerer in Austria and Hansen in Denmark, while in the USA the Bogardus brothers were meeting a healthy demand for cartes before the 1861 outbreak of the Civil War. Quantities of German albumen paper were shipped out to satisfy American demand, vast numbers of British carte mounts were produced by French and German companies, and the French firm of Marion thrived in the UK as a major photographic supplier. Union cases, patented in the USA by Samuel Peck, were soon exported to Europe, and some, it is believed, came to be manufactured on this side of the Atlantic. Cameo medallion portraits, devised in Italy in 1870, reached these shores the very next year, and the Victorian age ended with American roll film about to conquer the world.

This sense of a photographic global village is also apparent in the images themselves. Conventions of composition and studio setting seem to have had much in common, and, though they drew to a degree on local imagery, even mount designs showed some similarities in their evolution towards elaboration. Costume and the appearance of people can sometimes look different, but there is much, too, that cuts across national boundaries, especially when it comes to women's clothes.

In general terms, then, when faced with pictures from abroad, it is reasonable to test them against known guidelines. Caution should be exercised over conclusions, and more mutually supporting pieces of evidence may be required than for a British photograph. But there is, at least, no need to abandon all attempts at making sense of photographs from overseas.

The United States

One country requires particular comment, for important work has been done on dating in the USA. William Darrah studied some 40,000 examples before producing *Cartes de Visite in Nineteenth Century Photography*. The application of his sometimes very precise findings to Cisatlantic cartes would probably not prove very profitable, but where family historians have American pictures to date, they might find his conclusions helpful. Some of them rely, as indicated earlier, on making very precise measurements, and some relate to the very earliest cartes, of which few survive in family collections. But there are others that are more easily tried out. He found mount illustrations of cameras and cherubs as early as 1865, and landscape format designs on the backs from 1868 onwards. Faint geometric or floral patterns, on which studio details and design features were overprinted, was a style he attributed to the 1880s. More details of Darrah's findings can be viewed at the City Gallery website mentioned in the bibliography.

But the carte de visite did not enjoy quite the same dominance in the States as in Europe. The popularity of the daguerreotype took longer to eclipse: the process became less expensive and it survived into the 1860s. The tintype – or ferrotype – also enjoyed greater and longer prominence in the New World. Winning favour in the late 1860s, it came to occupy a rather more elevated social niche than it did in Britain.

One last detail unique to the dating of American cartes might be mentioned. On the back of photographs from the United States a postage stamp was, for a short time, used to indicate the payment of tax. Such a stamp is evidence that the picture dates from the period between late summer 1864 and late summer 1866.

Copying Photographs

Modern methods

The family historian may be the outright owner of a number of ancestral pictures, but there are often others that have to be borrowed, copied and returned. Some fading or fragile pictures may also need to be reproduced to ensure the survival of the images they bear. Sometimes, too, it is desirable to have duplicate pictures to pass on to relations, in appreciation of information given or to prompt further memories. Modern technology has made the necessary copying very easy.

For some purposes, such as circulating pictures for suggested identification of the subject, a photocopy will do very well. Many modern copiers give very reasonable results. If there is ready access to a machine, the researcher can try adjusting the tone and can make more than one attempt. If it is necessary to pay for copies at a shop, it is worth considering which of the local businesses is most likely to have the latest and best-maintained machine. It may be worth paying a few pence more for better quality. Advanced equipment at the local print shop will produce results far superior to those of the photocopier tucked away at the back of the newsagents on the corner. A good machine can also enlarge the original, and this can prove very useful.

Once print shops and high street photo-labs come into the reckoning, digital copying and printing systems can be considered. These are more expensive than the simpler kinds of copying, but they can produce high-quality pictures on more durable paper, they can enlarge all or part of the original, and they can offer some cosmetic manipulation of the image. Some outlets now have customer-operated equipment that allows you to transfer your pictures to CD, and further refinements of imaging technology can doubtless be expected.

Then there is the possibility of do-it-yourself digital copying. Photographs can be scanned into a personal computer, manipulated, stored and printed. It's a possibility that those at ease with new technology are already likely to

have explored. Others will follow at their own rate, or will enlist the help of a friend or relation who is already furnished with the necessary equipment and enthusiasm.

The Traditional Method

There remains, however, the old-fashioned possibility of making photographic copies of photographic originals. Many readers will consider this notion distinctly quaint. But for any who find in it a certain aptness (and who already have a suitable camera), a brief outline of the traditional procedure may be of use.

The first necessity is a single lens reflex (SLR) camera with through-the-lens metering. It is loaded with colour print film, since this reproduces the warm tone of old pictures, which are rarely simply black and white. Relatively slow film, say ISO (or ASA) 50 or 100, produces the sharpest image, but ISO 200 film produces results that many people find quite acceptable.

It is impossible to bring a standard camera close enough to a small object, such as a photograph, for it to fill the frame without the image becoming blurred and out of focus. This problem is overcome by adding close-up lenses or an extension tube or bellows to the camera. Each of these devices allows the photographer to move in very close to the subject without losing focus, and it can be possible to fill the frame with even a carte de visite. Of these additions, sets of close-up lenses are the cheapest.

The next requirement is a copy-stand or tripod to hold the camera steady and pointing downwards at the original, which lies on a flat, horizontal surface. (Attempting to fix the original to a vertical surface can cause it damage, and it is much harder to be sure that the camera is square on to a vertical subject.) When positioning the camera, the photographer should allow for the fact that, even though SLR cameras let us see what the lens sees, they take in a little more than can be seen through the viewfinder.

Flash is not a suitable form of illumination. Two photoflood lamps, each lighting from a side, can be positioned to avoid glare. A sheet of glass can be used to hold down the original and prevent it from curling in the heat of the lights. Since artificial lighting creates a warm colour cast on normal daylight film, the camera will have to be fitted with a daylight-to-artificial-light conversion filter.

With original and camera both in position and with lighting set up, it just remains to take the picture. Set the exposure according to the meter reading, taking two pictures on slightly different settings if in doubt. The use of a cable-release mechanism bypasses any chance of the hand causing the camera to shake. The exposed film can then be processed in the usual way at the local shop of your choice. If more than one copy of a picture is wanted, it is worth bearing in mind that a series of identical shots on the same film usually costs less than a series of prints made from the same shot.

Cheating

The method so far described is the standard one adopted by serious photographers. There is, however, a simplified method that can be used by those who are less meticulous. The SLR camera and a close-up attachment are still needed, but copy-stand, photofloods, conversion filter and cable-release can all be dispensed with. Whether or not the method is satisfactory is very much up to the individual.

The camera is hand-held and natural light is used. There is no need to set up shop out of doors; a well-lit indoor site, such as a desk or table at a window, is suitable. Even bright, direct sunlight is not necessary; good indoor daylight will do. Of course, it is necessary to use a film that reacts more quickly to the light. ISO 400 films are readily obtainable and serve very well. It is true that faster film speeds tend to produce grainier results, but in practice an effect which might be noticeable on a slide (which is much magnified in projection) may be negligible on a postcard-sized print.

Since the original is placed on the desk or table top, the photographer has to lean over, pointing the camera downwards. Because the light is coming from the other side of the desk, it is usually easy to avoid casting an unwanted shadow. (The use of natural light, incidentally, obviates any need for conversion filters.) With the close-up lenses (or more expensive equivalent) in place, and with the focus set down to its shortest distance, one moves oneself and the camera up and down until the picture is clear and then, with exposure set according to metering, takes the picture. Since human error is very possible with this method, it is a good idea to make assurance doubly sure by taking a second shot.

Though open to criticism, this method is still likely to improve on the original, since modern copies often have a cosmetic way with imperfections and restore lost contrast. The worn edges of an original can be cut out by bringing the camera a little closer, and the end product can be surprisingly pleasing. The pure- and high-minded will not be satisfied with such an arbitrary procedure; but lesser mortals, willing to have a go, may be very happy with the results.

Looking after Old Photographs

Photographs are not for ever. They are fugitive images on fragile or flimsy material, and they are patently vulnerable. Nevertheless, many have lasted far longer than the people they depict, thanks in part to their sentimental value and to an unwillingness to throw them away when all about them is consigned to the bonfire or the tip. But our early pictures, which have hitherto survived the process of growing old – the wear and tear of being handled, the rough and tumble of storage in a shoe box or the back of a drawer – are still at great risk. Excessive heat and dryness can make them brittle and likely to crack; moisture, especially in warm conditions, can promote fungal growth; chemicals, contained both in the pictures themselves and in the materials they are stored in, can interact, stain and cause fading.

Faced with a threat to valuable possessions, the owner can do two things: look after them safely, and take out insurance. In the case of photographs, insurance amounts to making copies. Where, as with family portraits, the image is of at least as much value as the artefact, it makes sense to provide oneself with duplicates. As for looking after pictures, the steps to be taken are up to the individual. Effective conservation of a collection of photographs can be a costly business, and the notes that follow may in places go beyond what a non-specialist collector feels able to do. But they also cover common-sense measures that can be taken without undue expense.

Handling and Using

In art galleries we go along readily enough with instructions not to touch the exhibits. What is good for the Mona Lisa is good enough for great-great-grandma. Even clean skin exudes chemicals. So photographs should be handled only at the extreme edges, adding support from the back if necessary; touching the actual image should be avoided. A pair of white cotton gloves from the local chemist's shop is worth considering.

Once photographs have been identified, they need to be labelled in some way. Adhesive labels are to be shunned, for they peel off in time, leaving a stain. Ink markings on the back could eventually bleed through to the face of

the photograph, and hard writing implements engrave their message, so that a few words on the reverse are liable to give an unwanted relief impression on the image itself. A soft lead pencil, such as a 6B, is gentler in its action. It can also, if required, be erased, thus enabling one to abide by the dictum that nothing should ever be done to a photograph that cannot be reversed. The amount of writing on the back can be reduced by the use of reference codes, linked to detailed notes recorded separately. Where photographs are kept in an old family album it is possible, as previously indicated, to keep records without marking the pictures at all.

Light
The light that made photographs can also destroy them. Fading caused by chemicals used in the original process may not be avoidable, but bleaching in the sunlight is. Artificial light is no great friend to photographs either, but fluorescent light is particularly hostile, being rather similar to the sun in its effect.

It follows that photographs should be stored in the dark. Often, however, there is a wish to display some of them. Such pictures should be placed where they do not bask in natural light as it moves around the room. The window wall itself is usually protected, unless there are windows in more than one wall, and other walls may prove to be well shaded. When the direction of light is considered, it should be borne in mind that this varies not just with time of day but also with time of year: the low winter sun may seek out spots that remain relatively shaded in summer.

There is, of course, a simple solution to the problem of display, and that is to put only copies on view, keeping the originals tucked away in the gloom.

Temperature and Humidity
A relatively dry environment should be sought in which to keep photographs. Too dry an area can, admittedly, cause its own problems, such as encouraging silverfish (which like nothing better than a good meal of gelatin). But the fact remains that humidity is the most alarming cause of deterioration in photographs.

Relative coolness is also desirable, as heat can damage and can add to the dangers of both excessive dryness and excessive humidity. Particularly to be

avoided is a place with varying extremes of temperature, for a photograph is made up of a number of layers, each of which expands and contracts at its own rate as it warms and cools.

It may not be possible to control the home as if it were a professional archive, but dryness and reasonable constancy of moderate temperature can be aimed at. With such considerations in mind, certain domestic storage sites are clearly unsuitable. Living rooms are likely to become very warm, for humans like to be cosy. Such rooms may even have a live fire, and coal gives off by-products that are potentially harmful. Kitchens and bathrooms are steamy, attics are dusty, garages are for cars and their emissions, and the temperature in conservatories has all the steadiness of a yo-yo. When unthinkable places have been ruled out, what is left is likely to be a bedroom or perhaps a study, and, even there, proximity to a heating source is undesirable.

Storage

Once a room has been chosen, storage containers and materials have to be selected, for the photographs need to be protected from dust. Dust, after all, is free-range sandpaper. But storage presents its own problem, since chemically inert materials do not grow on trees.

Wood does grow on trees, and it contains lignin, a cell-stiffening substance inimical to photographs. Cabinets and boxes of new or untreated wood are therefore not recommended. Old, seasoned wood, however, is likely to have passed its avoid-by date. Metal shelves and cabinets are generally considered safe, as long as they are enamelled rather than painted.

Inside a cabinet there is likely to be a need for sleeves, envelopes or wrappings. Paper and cardboard are the obvious materials, but if made (as they almost certainly will be) from wood pulp, they too contain lignin. Some plastics are also highly suspect. Pure polyester and polypropylene are currently considered acceptable. Pure polythene is chemically inert, though its dull finish may be held to compromise its transparency. But other kinds of plastic are warned against, and PVC is rated Public Enemy Number One, because the chemicals employed in its manufacture can migrate to those surfaces that it touches. It is possible to obtain safe plastic sleeves and paper made from cotton or purified wood fibre, and further details may be found in

the books mentioned in the bibliography. It should be added, to increase the reader's sense of depression at this point, that views on what is safe could well change, since the problems relating to any one storage material — especially one that is new — might become apparent only with the passing of time.

Photograph albums are a further problem, and the ideal album has probably yet to be produced. Certainly those modern albums that use self-seal transparent pages should be approached with suspicion. Where an adhesive coating has been used, it can discolour with remarkable speed, and many photographers will no more use such albums for their new pictures than for their treasured heirlooms. Old albums may by now be relatively safe, and there is a strong argument for retaining them. The ordering of photographs within them may in itself be informative, and their window mounts offer good protection. Indeed, window mounts are an effective device for retaining pictures. In their absence, hinges may be made using a genuinely water-soluble adhesive and not, it need hardly be said, sticky tape. Corner mounts may also be considered. What they are made of is not always stated on the packaging, but acid-free products can be found, and at least they come into contact with only a very small area of the photograph.

Photographs and celluloid negatives should normally be stored horizontally. If they are kept upright, they should be packed firmly enough to insure against curling or slipping. Glass negatives in any number should not be stored flat, because of the considerable weight that those at the bottom of a pile would have to bear.

The earliest celluloid negatives are highly combustible. In practice, self-ignition is only likely in very warm conditions and when the negatives are already in an advanced state of decomposition. Nevertheless it would seem sensible to store any such negatives separately in a cool, dry place, neither tightly nor airtightly packed, and to check their condition periodically.

Prevention and Cure
The owner of old photographs must decide what kind of protection it is reasonable to attempt. Compromises may have to be made, and I confess to practising less than I preach. It is, however, evident that some thought and care are worthwhile.

If first-aid measures are required to repair or retouch, expert advice should be sought. Amateur retouching can be attempted on a copy, but unschooled ministrations to creased, torn or damaged originals are not recommended. Heroic conservation, like heroic surgery, is the province of the professional. At most, one might be tempted to place (not stick) black paper of known quality behind a flaking ambrotype, or to clean the back of a grubby card mount with a piece of bread or a very soft and crumbly eraser. But the kind of recipe once offered for rejuvenating images — washing tintypes in alcohol, say, or subjecting daguerreotypes to a complicated series of chemical baths — would seem to be best avoided.

Modern technology does, however, open up one avenue for exploration. Interesting experiments in image enhancement, restoration and repair can be carried out on a picture that has been scanned into a computer. What's more, they can be performed without risk of further damaging the original.

Photographs and Dating Charts

The pictures and charts that follow form a kind of reference section.

To allow comparison of mounts, studio settings and clothes to be more quickly and easily made, the illustrations are grouped together by theme, rather than distributed through the text. Figures 1-8 show a series of types of photograph; figures 9-12 focus on mount design; figures 13-36 trace costume and setting through the decades.

It should be borne in mind that dates on the charts can often be only approximate. In particular, practices may have survived with individual photographers and clothes in individual families rather later than can be indicated by any general statement about dates.

Figure 1: Ambrotype; photographer unknown. Cased. The buttons and jewellery have been touched with gilt.

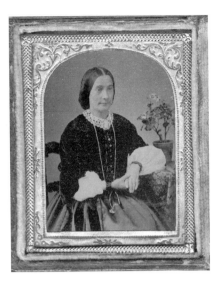

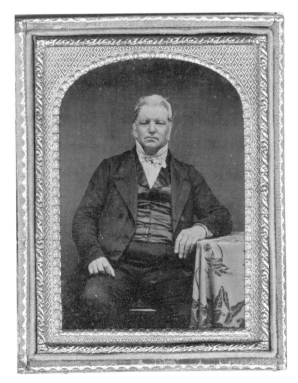

Figure 2: Ambrotype; photographer unknown. Cased. The reversed position of the buttons reminds us that an ambrotype is actually a treated negative.

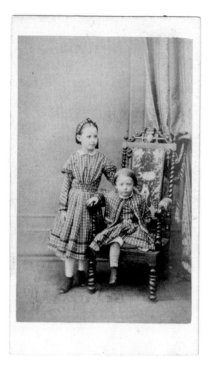

Figure 3: Carte de visite; Howard, Bourne & Shepherd, Simla. Harriet & Robert Hewsole, 1864. Tartan was popular for children, and Robert has yet to graduate into breeches.

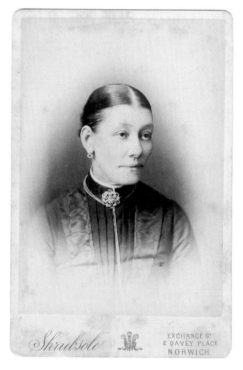

Figure 4: Cabinet print; Shrubsole, Norwich. The vignette effect was much favoured in the 1890s. Comparison of the photographer's address with Norwich directories puts the date at about 1892.

Figure 5: Tintype; photographer unknown. Framed, unglazed. This small tintype is brighter than many, but the emulsion has bubbled and the oval shape in the pinchbeck has been cut roughly by hand.

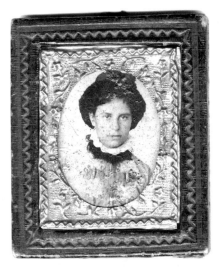

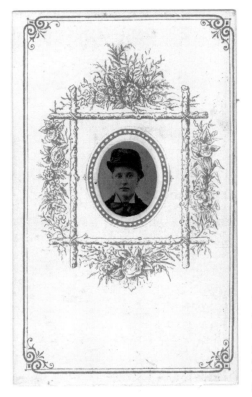

Figure 6: Gem tintype; Taylor's American Gem Studio, Bradford. The picture has been mounted to fit into a carte album, and is held in place by a patch of paper stuck on the back.

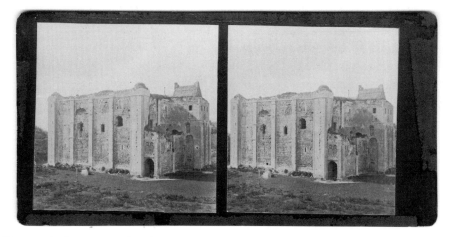

Figure 7: Stereo card; photographer unknown. Castle Rising Castle. No ancestral link, but now the author's neighbourhood Norman castle.

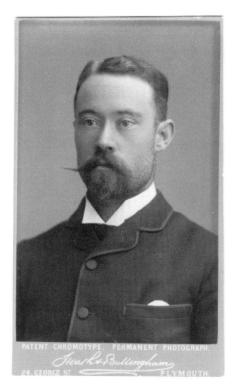

Figure 8: Carte de visite; Heath & Bullingham, Plymouth. Chromotype process. Image and trade information are brought together on a single photographic surface by a process that found limited favour in the mid-to-late 1870s.

Figure 9: Carte de visite mount; Mrs E. Higgins, Stamford. 1860s trade-plate back, showing signs of the taste for greater ornamentation that was to follow.

Figure 10: Carte de visite mount; Brown, Barnes & Bell. Extensive publicity material includes royal arms and Prince of Wales' feathers. Lack of Mount Pleasant address suggests the end of the 1880s.

Figure 11: Carte de visite mount (reverse of Figure 26); C. S. Allen, Tenby. The photographer claims royal patronage, but held no warrant, so the mount is likely to be pre-1884.

Figure 12: Carte de visite mount; F. Walton, Leeds. A cherub photographer with butterfly wings dominates this pictorial mount, but the taste for orientalism, indicated by the fan, should not be overlooked.

Figure 13: Carte de visite; photographer unknown. The simplicity of setting and hairstyles, the sloping shoulders, the full skirts, and the hidden ears of the oldest girl combine to suggest the first half of the 1860s. Note that skirt lengths relate to age.

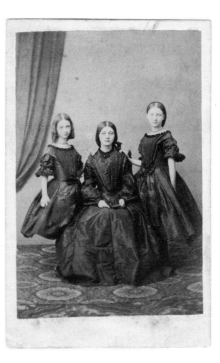

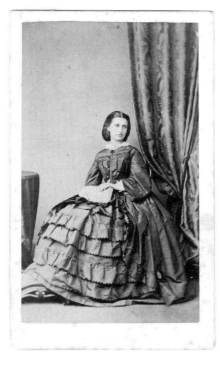

Figure 14: Carte de Visite; Stuart of Glasgow. Squared corners, simple setting & full-length seated figure all indicate the 1860s. Directories do not help with dating, since John Stuart conducted business at this Buchanan Street studio for 50 years or more.

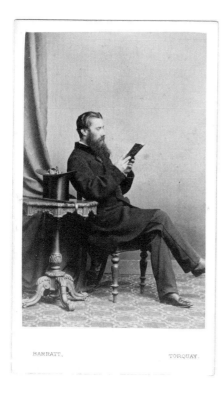

Figure 15: Carte de visite; Barratt of Torquay. The full-length seated figure in a simple setting is characteristic of the 60s, and the curved line of the hat's brim points to the second half of the decade.

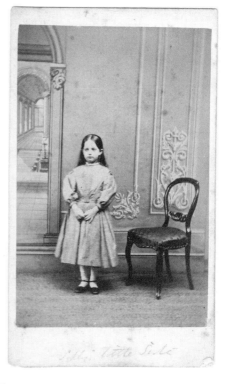

Figure 16: Carte de visite; I. Bradley, Leicester. Squared corners and classical studio setting, with chair as ornament rather than seat, suggest the late 1860s for this portrait of 'Sophie's little sister'.

Figure 17: Carte de visite; photographer unknown. The wide, supportable skirt and the geometrical decoration of the bodice belong to the 1860s, and the backcloth to the last years of the decade.

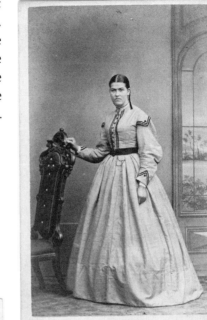

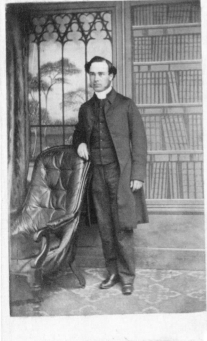

Figure 18: Carte de visite; J. Saunders, Lowestoft. The chair for leaning on and the window giving on to a rural scene point to the late 60s (or possibly the early 70s). Evidence from trade directories suggests 1868/9.

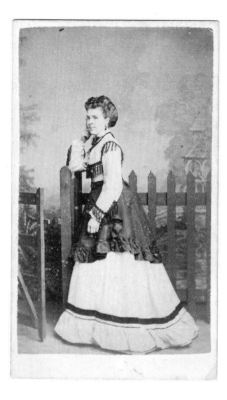

Figure 19: Carte de visite; Stuart Brothers, Knightsbridge. Outdoor set with fence and gate, sloping bustle, fringing and mixture of materials indicate the 1870s, and the epaulette effect went out early in the decade. The carte is dated September 1871.

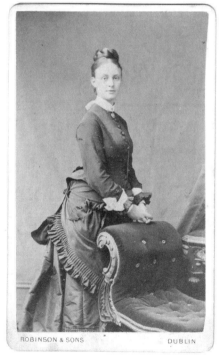

Figure 20: Carte de visite; Robinson & Sons, Dublin. The swathes of the bustle and the frill on the skirt seem to belong as much to the world of upholstery as to that of clothing. The camera is closer to the subject than in the 60s.

Figure 21: Carte de visite; photographer unknown. The picture is mounted on a thin, uninformative piece of card, but the fussiness of neck and cuffs, as well as the architecture of the hair, point to the 1870s.

Figure 22: Carte de visite; R. W. Gibbs & Co., Middlesborough. The 1870s taste for elaboration is much in evidence, not least in four different finishes to the neckline. The three-quarter-length figure is characteristic of the time.

91

Figure 23: Carte de visite; Grant, Warminster. The slightly raised central medallion, with its cameo vignette effect, first became popular in the early 70s.

Figure 24: Carte de visite; Henry Gregson, Luton. Jabots, heavily trimmed dresses, skirts bunched back, sleeves set in at the shoulder and padded lectern all speak of the 1870s. Skirt and trouser lengths, like the girls' hair worn down, are signs of junior status.

Figure 25: Carte de visite; Cromack, Scarborough. The high, jutting bustle suggests that the picture belongs to the first half of the 1880s.

Figure 26: Carte de visite (front of Figure 11); C. S. Allen, Tenby. Masonry made a comeback in studio settings of the 80s, but there is some texture to the artificial stone, and the painted pillars are ivy-clad. The tousled fringe is also characteristic of the time.

93

Figure 27: Carte de visite; J. A. Sykes, Lindley. Annie Kay, aged 18, sits in front of choppy canvas waves with a romantic pile in the background. The carte is dated 18th March 1888.

Figure 28: Carte de visite; E. Kelley, Newton Abbott. Tight bodice and sleeves, the slightly military look and the heavily feathered hat all place this portrait in the 1880s.

Figure 29: Carte de visite; W. Nicholls & Son, Lichfield. An 80s origin is indicated by the smooth, close-to-head hairstyles, the high necklines and the daughter's piecrust collar. There is still plenty of ornamentation, but, compared to the 70s, the look seems almost severe.

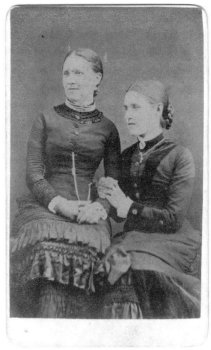

Figure 30: Cabinet print; Parisian School of Photography, London. The ornate mount could belong to 80s or 90s, but the Fauntleroy look is more closely associated with the earlier decade, and that, too, is when the company's Fleet Street Studio flourished.

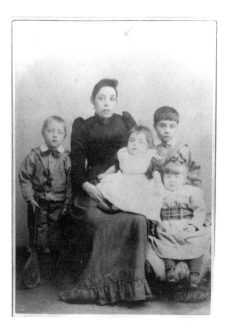

Figure 31: Modern copy of a cabinet print; photographer unknown. Edith Pols, with her first four children, 1893/4. If the children's ages didn't date the picture, their mother's sleeves would. The sailor look was still popular and the taste for tartan was not wholly dead.

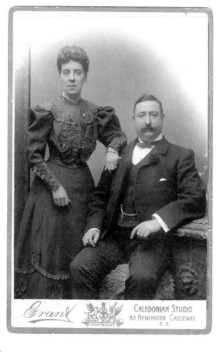

Figure 32: Cabinet print; Grant of London. The mount is gold trimmed and has a dark back. The leg-of-mutton sleeves belong to the middle of the 1890s.

Figure 33: Carte de visite; Hellis & Sons. Another example of leg-of-mutton sleeves, this time as part of a less formal look. The 90s were the heyday of the Hellis chain, and the mount lists 11 branches in addition to the main studios in Regent Street.

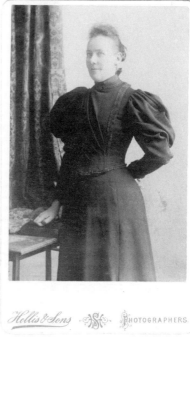

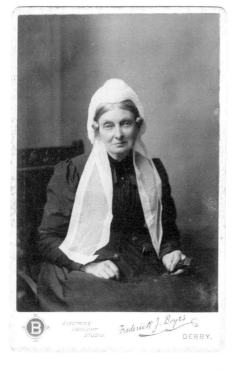

Figure 34: Cabinet print; Frederick J. Boyes, Derby. The sitter looks surprisingly young to be still wearing a taped indoor cap in (as reference to an 1893 medal on the reverse reveals) the middle or late 1890s.

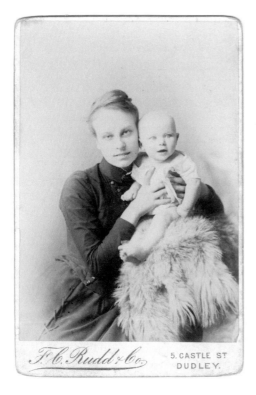

Figure 35: Cabinet print; F. C. Rudd & Co., Dudley. The baby's bare-legged and off-the shoulder look is an innovation of the 1890s. The cream card with gold printing and blank back is characteristic of the new restraint in mount design.

Figure 36: Carte de visite; T. Smith & Sons, King's Lynn. This dark-mounted carte shows the love of lace on blouses which grew up in the 1890s. The vignette effect is typical of the time.

98

DATING CHART 1
The Processes and Formats

45	50	55	60	65	70	75	80	85	90	95	00

<---------------- ->

calotypes cartes de visite

<--------------- - - - - - ->

daguerreotypes cabinet prints

- - - - - - - - -

ambrotypes (good quality) small postcards

- - - - - - - - - - ->

ambrotypes (poorer quality) roll film

- ->

x (1854) - - - - - - - - - - - -
union case introduced gem tintypes

- ->

stereos

- -

albumen prints

- ->

carbon prints

- - - - - - - - - - -

chromotype

- ->

platinum prints

- - - - - - - - - - - - - - - ->

promenade prints gum bichromate

x (1872) ->
Van der Weyde process pictures on enamel

- ->

opal glass prints

| 45 | 50 | 55 | 60 | 65 | 70 | 75 | 80 | 85 | 90 | 95 | 00 |
|----|----|----|----|----|----|----|----|----|----|----|----|

DATING CHART 2

The Mount

| 1850 | 1855 | 1860 | 1865 | 1870 | 1875 | 1880 | 1885 | 1890 | 1895 | 1900 |
|------|------|------|------|------|------|------|------|------|------|------|

C: simple trade plate backs C; highly elaborate & informative backs

S: publisher not named C: more ornate backs, C: backs often with pictures
all-over design

S: card may be very thin C: Japanese motifs

C: (cartes) thin card C: card increasingly stout and inflexible

C: no studio details on front C: bevelled edges

C: US stamp C: some coloured card C: new simplicity

C: corners generally rounded

S: yellow card C: occasional squared corners

S: variety of possible card colours

S: corners generally square C: dark card, pale lettering

C: square-cut corners S: corners often rounded

S: possibility of publisher's name in margin

S: pale grey card S: possibility of information on back

| 1850 | 1855 | 1860 | 1865 | 1870 | 1875 | 1880 | 1885 | 1890 | 1895 | 1900 |
|------|------|------|------|------|------|------|------|------|------|------|

| C = cartes and/or cabinet prints | S = stereos |
|---|---|

The Professional Studio

| 1860 | 1865 | 1870 | 1875 | 1880 | 1885 | 1890 | 1895 | 1900 |
|------|------|------|------|------|------|------|------|------|
| . | . | . | . | . | . | . | . | . |

- - - - - - - - - - -----------------------------

use of electric lighting

--

false claims to royal patronage not uncommon

false display of royal arms/warrant unlikely

-->

A & G Taylor chain in London

--->

Taylor chain in provinces

Taylor studios overseas

--->

Brown Barnes & Bell in Liverpool

Brown Barnes & Bell at Mount Pleasant

--->

Brown Barnes & Bell in London

------------- - - - - - -

Brown Barnes & Bell peak

<-- - - - - - - - - - - - -

London School of Photography in London

London School in north

------------------------->

Hellis & Sons

| 1860 | 1865 | 1870 | 1875 | 1880 | 1885 | 1890 | 1895 | 1900 |
|------|------|------|------|------|------|------|------|------|

Royal Warrants

| An alphabeitical table of Victorian photographers and studios granted royal warrants |
| --- |

| Photographer/studio | Date |
| --- | --- |
| Abernethy, W | 1900 |
| Annan, J & R | 1889 |
| Backofen, Karl | 1885 |
| Barnes, Brown, & Bell | 1886 |
| Bassano, Alexander | 1890 |
| Bell, Brown, Barnes & | 1886 |
| Braun, A, & Co | 1885 |
| Brogi, Cavaliere Carlo | 1888 |
| Brown, Barnes & Bell | 1886 |
| Burin, F | 1891 |
| Cartland, George Piner | 1887 |
| Chancellor & Son | 1899 |
| Claudet, Antoine | 1855 |
| Collier, John | 1885 |
| Dayal, Reja Deen, & Son | 1897 |
| Degard, Eugene | 1882 |
| Disderi, Adolfe | 1867 |
| Downey, William & Daniel | 1879, 1890 |
| Fall, Thomas | 1897 |
| Fox, Herbert, & Fred Glover (trading as Maull & Fox) | 1900 |
| Glover, Fred, Herbert Fox & (trading as Maull & Fox) | 1900 |
| Grove, William H | 1899 |
| Henderson, A L | 1884 |
| Hills, Robert & John Henry Saunders | 1867 |
| Hughes & Mullins | 1885 |
| Horne, J, & Thornthwaite | 1857 |
| Gunn, Charles, & William Slade Stuart (trading as Gunn & Stewart) | 1896 |
| Julien, Stanilas, Comte Ostorof (trading as Valery) | 1886 |
| King, Horatio Nelson | 1896 |
| Lafayette, James | 1887 |
| Lee, Edwin P, & Co | 1875 |
| Lettsome & Sons | 1890 |
| London Stereoscopic & Photographic Company | 1895 |

| Photographer/studio | Date |
|---|---|
| Marcossi, C | 1880 |
| Maull & Fox (Herbert Fox & Fred Glover) | 1900 |
| Milne, Robert | 1896 |
| Mullins, Hughes & | 1885 |
| Murray, Robert Charles | 1872 |
| Oldham, William | 1897 |
| Ostorof, Comte (= Stanilas Julien, trading as Valery) | 1886 |
| Poullan, M P, Fils | 1892 |
| Ross, James, & John Thompson | 1849 |
| Russell, J L, A H & E G (trading as Russell & Sons) | 1897 |
| Saunders, Frederick & Ernest (trading as Hills & Saunders) | 1893 |
| Saunders, John Henry, Robert Hills & | 1867 |
| Steen, Mrs Mary | 1896 |
| Stuart, William Slade, Charles Gunn & (trading as Gunn & Stewart) | 1896 |
| Taylor, A & G (Andrew & George) | 1886 |
| Thompson, John, James Ross & | 1849 |
| Thompson, John | 1881 |
| Thornthwaite (J Horne &) | 1857 |
| Uhlenhuth, Professor E | 1897 |
| Valentine, James | 1868 |
| Valery (Stanilas Julien, Comte Ostorof) | 1886 |
| Voigt, Thomas Heinrick | 1885 |
| Welch, R | 1900 |
| Whitlock, H J | 1870 |
| Wilson, Charles Andrew | 1887 |
| Wilson, C A, J H & L (trading as G W Wilson & Co) | 1895 |
| Wilson, George Washington | 1873 |

DATING CHART 5

Setting and Composition

1860 1865 1870 1875 1880 1885 1890 1895 1900

--------------------------- ---------------------------
outdoor sets, 'natural' backdrops white fur for babies
stiles, fences, bridges, foliage (often painted)

--------------- - - - - - ---------------------------- - - - - - - - - - -
neutral backgrounds, elaborate outdoor sets, swings, tussocks, rocks,
simple settings, curtains hammocks; occasional railway carriages

--------------- - - - - ---------------------------
interior-to-exterior view exotic set details, pot plants,
through window or arch mirrors, palms, cockatoos

--------------------------- - - - --------------------------- - - - - -
classical look, drapes, columns, revival of balustrades and
balustrades, plinths, arches plinths, often more weathered

-------------------------- - - - - - - ---------------------
some seaside backgrounds bicycles

--------------------------- --------------------------- - - - - -
full-length figure (standing setting emphasises texture
or sitting), feet visible of surroundings

--------------------------- ---------------------------
seated subjects often reading outdoor sets highly artificial

--------------------------- - - - - - - ---------------------
seats more for leaning on than sitting head & shoulders shots

--------------------------- - - - - - - ---------------------------
chairs increasingly elaborate, with vignettes
padded backs, fringes; padded rests, lecterns

- - -------------------------------- ------------
three-quarter length figures genuine exteriors (roll film)

--------------------------- - - - - - - --------------------------- - - - - - -
headrest base visible masthead & rigging sets

--
cameo medallion/cameo vignette

1860 1865 1870 1875 1880 1885 1890 1895 1900

Women's Fashion — General Line and Decoration

| 45 | 50 | 55 | 60 | 65 | 70 | 75 | 80 | 85 | 90 | 95 | 00 |
|----|----|----|----|----|----|----|----|----|----|----|----|
| · | · | · | · | · | · | · | · | · | · | · | · |

------------- ---------------- - - - - --

sleeves fairly geometrical patterns tight corsetry
close-fitting

- ------------------- - - ----------------------

complicated designs; mixture skirts plain; fashion
of colours & materials in emphasis on top
same dress half of body

- - - - ------------------------ - - - -------- - - - -

crinolines high, jutting bustle

------------------------------ --------------------

bodice above crinoline cut basic dress design plainer, but
to mould figure much decoration still added

x 1871 - - - - - - -------------------------
Dolly Varden dress tailored suit with blouse
introduced

-------------- - - ------------- ----------------------

skirts smooth & princess line; waist jet & lace
bell-shaped tight, long, coming to point

------------- - - - - - ----------

sloping bustle leg-of-mutton sleeves

---------------- - - - - ----------------------

Greek key pattern 'natural history' decoration on
hats and dresses

---------------------- ----------------------

lots of trimmings, frills, 'natural history' decoration
ribbons, stitching, more subdued,
buttons, fringing mainly on hats

| 45 | 50 | 55 | 60 | 65 | 70 | 75 | 80 | 85 | 90 | 95 | 00 |
|----|----|----|----|----|----|----|----|----|----|----|----|

Women's Fashions — Bodice, Sleeves and Skirt

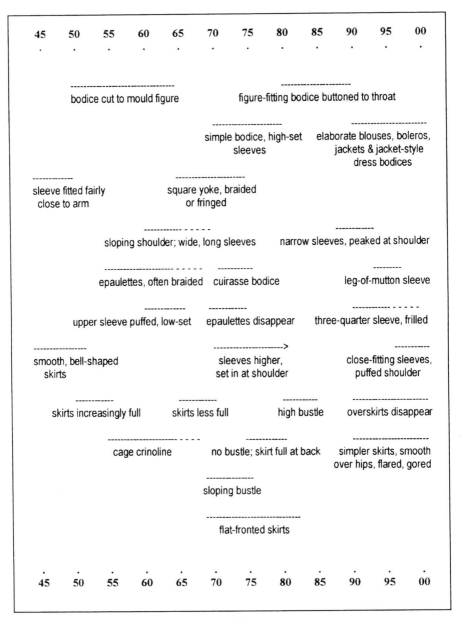

| 45 | 50 | 55 | 60 | 65 | 70 | 75 | 80 | 85 | 90 | 95 | 00 |
|----|----|----|----|----|----|----|----|----|----|----|----|
| . | . | . | . | . | . | . | . | . | . | . | . |

```
-------------------------------                 ----------------------
bodice cut to mould figure              figure-fitting bodice buttoned to throat

                                ---------------------       -----------------------
                                simple bodice, high-set     elaborate blouses, boleros,
                                        sleeves             jackets & jacket-style
                                                                dress bodices
------------                         ----------------------
sleeve fitted fairly                 square yoke, braided
  close to arm                           or fringed

                        ------------ - - - - -                        -----------
                        sloping shoulder; wide, long sleeves     narrow sleeves, peaked at shoulder

            ----------------------- - - - - -   ------------              ---------
            epaulettes, often braided   cuirasse bodice              leg-of-mutton sleeve

                        ------------       ------------         ------------- - - - - -
                        upper sleeve puffed, low-set   epaulettes disappear    three-quarter sleeve, frilled

------------------                      ----------------------->          -----------
smooth, bell-shaped                       sleeves higher,               close-fitting sleeves,
    skirts                               set in at shoulder                puffed shoulder

      -----------                  -----------             ----------       -------------------------
      skirts increasingly full     skirts less full        high bustle      overskirts disappear

              ------------------------ - - - -         ------------         ----------------------
              cage crinoline                    no bustle; skirt full at back    simpler skirts, smooth
                                                                                 over hips, flared, gored
                        ---------------
                        sloping bustle

                        -----------------------------
                        flat-fronted skirts
```

| 45 | 50 | 55 | 60 | 65 | 70 | 75 | 80 | 85 | 90 | 95 | 00 |
|----|----|----|----|----|----|----|----|----|----|----|----|
| . | . | . | . | . | . | . | . | . | . | . | . |

Women's Fashions — Head and Neck

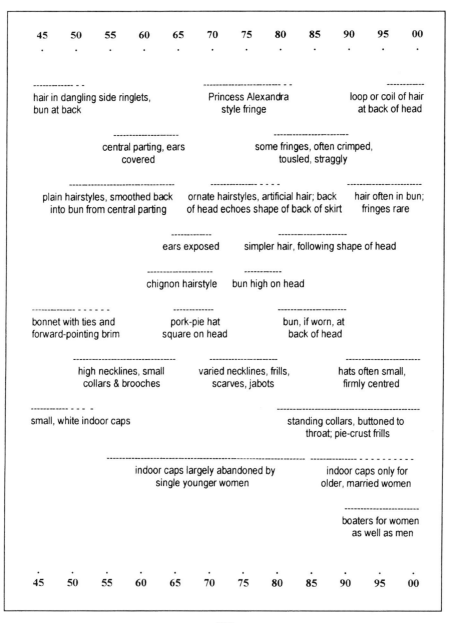

| 45 | 50 | 55 | 60 | 65 | 70 | 75 | 80 | 85 | 90 | 95 | 00 |
|---|---|---|---|---|---|---|---|---|---|---|---|

hair in dangling side ringlets,
bun at back

Princess Alexandra
style fringe

loop or coil of hair
at back of head

central parting, ears
covered

some fringes, often crimped,
tousled, straggly

plain hairstyles, smoothed back
into bun from central parting

ornate hairstyles, artificial hair; back
of head echoes shape of back of skirt

hair often in bun;
fringes rare

ears exposed

simpler hair, following shape of head

chignon hairstyle

bun high on head

bonnet with ties and
forward-pointing brim

pork-pie hat
square on head

bun, if worn, at
back of head

high necklines, small
collars & brooches

varied necklines, frills,
scarves, jabots

hats often small,
firmly centred

small, white indoor caps

standing collars, buttoned to
throat; pie-crust frills

indoor caps largely abandoned by
single younger women

indoor caps only for
older, married women

boaters for women
as well as men

| 45 | 50 | 55 | 60 | 65 | 70 | 75 | 80 | 85 | 90 | 95 | 00 |
|---|---|---|---|---|---|---|---|---|---|---|---|

DATING CHART 9

Men's Clothes — Trunk and Limbs

| 45 | 50 | 55 | 60 | 65 | 70 | 75 | 80 | 85 | 90 | 95 | 00 |
|----|----|----|----|----|----|----|----|----|----|----|----|
| · | · | · | · | · | · | · | · | · | · | · | · |

----------------------- -------------- -----------------------

tight suits, cut lounge suits with straight, narrow look
close to body deep cuffs to ensemble

------------------------- - - - - - ----------------------->

looser suits, wider sleeve & leg lounge suit very popular

----------------------- -------------------------

suits tighter, often double-breasted baggier look to suits

-------------- ----------------------- --------------------

fancy waistcoats reefer jacket for lower classes reefer jacket for sporty look

-- ------------------------------->

waistcoats may not match dinner jacket

-- - - - ---

dark jacket with light trousers waistcoats generally match

------------> ------------------------->

shorter jackets for younger men cummerbund

----------------------------------- -----------

raised side seams on trousers turn-ups for the dashing

--------- -------

first appearance of knickerbockers advent of blazer as sports jacket

----------------------------- ----------------------> -----------

peg-top trousers, often braided side seams for peg-top
striped or check evening dress trousers revival

pressed trousers

- - - - - - - ---------------------------------------

Norfolk jacket increasingly popular

yoked Norfolk jacket

| 45 | 50 | 55 | 60 | 65 | 70 | 75 | 80 | 85 | 90 | 95 | 00 |
|----|----|----|----|----|----|----|----|----|----|----|----|
| · | · | · | · | · | · | · | · | · | · | · | · |

Men's Clothes — Head, Neck and Feet

| 45 | 50 | 55 | 60 | 65 | 70 | 75 | 80 | 85 | 90 | 95 | 00 |
|----|----|----|----|----|----|----|----|----|----|----|----|

--- - - -
very high top hats

-------- curved sides to top hat brim

flat sided top hat brims

narrow top hat brims

top hat crowns often low

highish crowned top hats

boaters becoming popular

the age of the boater

top hat crowns often low

medium-crowned bowler, curved brim

pudding-basin bowler

very high shirt collars
(reaching 3" in 1899)

high coat & shirt collars,
large cravats

high-crowned bowler

--------------> ---------------->
narrower ties homburg becomes popular

large, loose cravats

--------------->
spats

shoes often squarish-toed

relatively pointed toes to shoes

| 45 | 50 | 55 | 60 | 65 | 70 | 75 | 80 | 85 | 90 | 95 | 00 |
|----|----|----|----|----|----|----|----|----|----|----|----|

Children's Clothes

| 45 | 50 | 55 | 60 | 65 | 70 | 75 | 80 | 85 | 90 | 95 | 00 |
|----|----|----|----|----|----|----|----|----|----|----|----|
| . | . | . | . | . | . | . | . | . | . | . | . |

sailor suits for boys

sailor top with skirt for girls

short crinolines for girls, showing pantaloons Little Lord Fauntleroy look

elaborate & complicated girls' dresses

smocked yokes a novelty

smocked yokes common

height of taste for dressing sisters alike

Scottish look popular

occasional off-the-shoulder shift, bare feet & legs for babies

full-length trousers for boys

trouser length according to age (dresses for very young boys)

some lace-up shoes

sombre, adult-looking clothes for both sexes

| 45 | 50 | 55 | 60 | 65 | 70 | 75 | 80 | 85 | 90 | 95 | 00 |
|----|----|----|----|----|----|----|----|----|----|----|----|
| . | . | . | . | . | . | . | . | . | . | . | . |

Bibliography

The organisation of books into categories is, inevitably, a little arbitrary. Many of them cover more ground than the group heading indicates, but each devotes a useful amount of attention to the topic under which it is listed.

Early Photography

A. Burnett Brown, R. Roberts and M. Gray, *Specimens and Marvels: William Henry Fox Talbot and the Invention of Photography* (Aperture, 2000)

B. Coe, *The Birth of Photography: the Story of the Formative Years, 1800-1900* (Ash & Grant, 1976)

P. Daniels, *Early Photography* (Academy Editions, 1978)

F. Dimond and R. Taylor, *Crown and Camera: The Royal Family and Photography* (Penguin, 1987)

A. Goldsmith, *The Camera and its Images* (Ridge Press, 1979)

I. Jeffrey, *Photography: A Concise History* (Thames & Hudson, 1981)

G. MacDonald, *Camera: A Victorian Eyewitness* (Batsford, 1979)

S. Richter, *The Art of the Daguerreotype* (Viking, 1989)

D. B. Thomas, *The First Negatives* (HMSO, 1964)

Victorian Studio Photography

J. Hannavy, *The Victorian Professional Photographer* (Shire, 1980)

J, Hannavy, *Victorian Photographers at Work* (Shire, 1997)

B. and P. Heathcote, *The First Photographic Portrait Studios in the British Isles, 1841 to 1855* (Heathcote, 2002)

A. Linkman, *The Victorians: Photographic Portraits* (Tauris Parke, 1993)

R. Pols, *Understanding Old Photographs* (Robert Boyd Publications, 1995)

Help with Identification, Interpretation and Dating

D. Cory, *The Carte de Visite*, in *Bygones 5*, ed. D. Joice (Boydell Press, 1980)

M. Ginsburg, *Victorian Dress in Photographs* (Batsford, 1982)

M. F. Harker, *Victorian and Edwardian Photographs* (Charles Letts, 1975)

A. Lansdell, *Fashion à la Carte: 1861-1900* (Shire, 1985)

A. Linkman, *The Photographic Multiple in the Nineteenth Century*, in *The PhotoHistorian, Number 110, January 1996* (Royal Photographic Society, 1996)

A. Linkman, *Brown, Barnes and Bell*, in *The PhotoHistorian, Number 111, March 1996* (Royal Photographic Society, 1996)

A. Linkman, *The Expert Guide to Dating Victorian Family Photographs* (Greater Manchester Record Office, 2000)

C. Osman, *The Studios of A. & G. Taylor*, in *The PhotoHistorian Supplement, Number 111, March 1996* (Royal Photographic Society, 1996)

R. Pols, *Looking at Old Photographs* (FFHS, 1998; Countryside Books, 1999)

R. Pols, *Family Photographs 1860-1945* (Public Record Office, 2002)

M. Pritchard, *A Directory of London Photographers 1841-1908*, 2nd edition (PhotoResearch, 1994)

D. Steel and L.Taylor, *Family History in Focus* (Lutterworth Press, 1984)

The Care of Photographs

E. Martin, *Collecting and Preserving Old Photographs* (Collins, 1988)

A. Linkman, *Caring for your Family Photographs at Home* (Greater Manchester County Record Office, 1991)

Collected Examples of Early Photography

There is a long series, published by Batsford, of places and special interests, with titles following the pattern of *Victorian and Edwardian Cambridge* (or *Northumbria*, or *Wales*, or *Railways*, or *Children*) *From Old Photographs*. Hendon Publishing has produced a series concentrating on early pictures of towns and cities, often under such a title as *Harrogate* (or *Grimsby*, or *Coventry*) *As It Was*. Another series focusing on places (often using the formula: *Xxxxxx in Old Photographs*) has been brought out under the Allan Sutton imprint. Not all such books, however, come as part of a series. Many areas have inspired their own one-off collections of early photographs, and a look through the local interest section of a good bookshop should produce examples.

More general collections also appear on (and disappear from) the market. Shops dealing in publishers' remainders can be a very rewarding hunting ground both for these and for the works linked to localities.

Websites

American Museum of Photography: *www.photographymuseum.com*

City Gallery: *www.city-gallery.com*

Daguerreian Society: *www.daguerre.org*

George Eastman House - International Museum of Photography: *www.eastmanhouse.org*

Royal Photographic Society: *www.rps.org*